# Draw Furries

W9-BZW-632

How to create anthropomorphic and fantasy animals

Jared Hodges and Lindsay Cibos

IMPACT
CINCINNATI, OHIO
www.impact-books.com

## ABOUT THE AUTHORS

Jared Hodges and Lindsay Cibos are an artistic duo specializing in illustrations and sequential art. They are the creators of *Peach Fuzz*, a graphic novel series about a ferret named Peach and her young owner. Jared and Lindsay have also written and illustrated a number of art how-to guides, including the book *Digital Manga Workshop*. They currently reside in sunny central Florida. Visit them on the Web at www.jaredandlindsay.com!

## ACKNOWLEDGMENTS

We would like to express our gratitude to:

Our family and friends for their love and patience while our lives were (once again!) consumed with book deadlines.

The fine people at F+W Media, including Pamela Wissman, for entrusting the creation of this book to us; our editor, Mary Bostic, for her insight and help along the way; and Wendy Dunning, for taking our words and art and nicely arranging them into the book you now hold in your hands.

Miu, Kelly Hamilton, Rose Besch and Marie Blankenship for graciously allowing us to include a sampling of their work in the gallery section.

The furry community for being an endless source of inspiration.

Charly the shih tzu and the neighborhood stray cats for their modeling assistance with the feline and canine characters.

And, of course, you, the reader.

*Thank you!*

**Draw Furries: How to Create Anthropomorphic and Fantasy Animals**. Copyright © 2009 by Jared Hodges and Lindsay Cibos. Manufactured in U.S.A. All rights reserved. No part of this book may be reproduced in any form or by any electronic or mechanical means including information storage and retrieval systems without permission in writing from the publisher, except by a reviewer who may quote brief passages in a review. Published by IMPACT Books, an imprint of F+W Media, Inc., 4700 East Galbraith Road, Cincinnati, Ohio, 45236. (800) 289-0963. First Edition.

**fw media** Other fine IMPACT Books are available from your local bookstore, art supply store or online suppliers. Visit our website at www.fwmedia.com.

16  15  14  13  12      7  6  5  4  3

DISTRIBUTED IN CANADA BY FRASER DIRECT
100 Armstrong Avenue
Georgetown, ON, Canada  L7G 5S4
Tel: (905) 877-4411

DISTRIBUTED IN THE U.K. AND EUROPE BY DAVID & CHARLES
Brunel House, Newton Abbot, Devon, TQ12 4PU, England
Tel: (+44) 1626 323200, Fax: (+44) 1626 323319
Email: postmaster@davidandcharles.co.uk

DISTRIBUTED IN AUSTRALIA BY CAPRICORN LINK
P.O. Box 704, S. Windsor NSW, 2756 Australia
Tel: (02) 4577-3555

**Library of Congress Cataloging in Publication Data**
Hodges, Jared.
  Draw furries : how to create anthropomorphic and fantasy animals / by Jared Hodges and Lindsay Cibos. -- 1st ed.
     p. cm.
  Includes index.
  ISBN 978-1-60061-417-0 (pbk. : alk. paper)
  1. Fantasy in art. 2. Anthropomorphism in art. 3. Drawing--Technique.
I. Cibos, Lindsay. II. Title. III. Title: How to create anthropomorphic and fantasy animals.
  NC825.F25H64 2009
  743.6--dc22                                    2009019609

Edited by Mary Burzlaff Bostic
Designed by Wendy Dunning and Doug Mayfield
Production coordinated by Matthew Wagner

## HOW WE WORK

Most of the images in the book were done with either Jared or Lindsay as the sole artist of the image, handling everything from the initial sketch to finishing touches. However, sometimes we'll collaborate on a picture, brainstorming ideas for poses and scenes, or dividing the art duties. For example, Jared drew the cat pair on the title page, and Lindsay colored them.

# Table of Contents

# Introduction

A bipedal, humanoid figure with spiny fur and a hedgehog snout strolls into the room. At his feet trots a winged pig, cheerfully singing to itself. Noticing you, they grin and invite you to join them. Encountering such whimsical characters in reality is somewhat unlikely (maybe when pigs fly!), but anthropomorphic animals abound in the imaginations of people everywhere.

The concept of furry characters (another term for anthropomorphic animals) is relatively new; it was popularized in the 1980s. But art and stories juxtaposing humans and animals can be traced back thousands of years. The ancient Egyptians, for example, had animalistic deities such as Anubis, who had the head of a jackal. Anthropomorphic kimono-clad foxes, raccoons, dogs, cats and other animals were a recurring subject in classical Japanese ukiyo-e artwork. Further historical examples of anthropomorphic animals can be found in Native American mythology and works of literature like Aesop's fables, wherein talking animals took the roles of humans.

Anthropomorphic animals also permeate pop culture. Who isn't familiar with animal animation superstars like Mickey Mouse or Bugs Bunny? Walk down the breakfast aisle at your local supermarket, and you'll encounter talking animal mascots adorning cereal boxes. Animal characters also commonly serve as mascots for sports teams and in company logos.

Clearly, there's a public fascination with anthropomorphic characters. Perhaps this is because an animal component can personify strength, speed or other characteristics, or imbue a character with a fantastical visual element. Or perhaps it's the concept of giving animal abilities to humanoid characters (and vice versa) that we find intriguing. Of course, there's also the appeal of animals in and of themselves.

Whatever the case, furry art exists all around us, and, chances are, you have an interest in drawing it. We're here to help! Throughout this book, we'll take you through the steps of creating a wide variety of animal characters, from stalking cats and yapping dogs to galloping horses and soaring birds. After you've mastered the drawing aspect, we'll go over tips for coloring your creations and, finally, show you how to create backgrounds for your characters to interact with. So, grab your art supplies and let's draw some furries!

**Menagerie**
by Jared Hodges
10" × 12" (25cm × 30cm)

# Furry Hybridization

Anthropomorphic animals are the resulting hybrid from mixing human and animal qualities. (*Anthropomorphism* means attributing human characteristics to non-human things.) The level of anthropomorphism depends on the artist's vision for her character.

To put it in other terms, think of a scale with humans on one side and animals on the other. As you slide across the scale, the character becomes either more human or more animal-like.

For example, when combining a human with a fox, you might choose to represent some of the fox's features, such as its pointy muzzle and bushy tail, on a human frame, resulting in a foxlike human character. Or, instead, you might add human expressiveness (human facial features, body language and the ability to talk) to a fox's body, resulting in a markedly different humanlike fox character. Although both examples start with the same two basic elements (a human and a fox), the characters are distinct.

As you create your own anthropomorphic animals, consider the features you wish to emphasize. Ask yourself if you want more animal or human elements showing through in your characters. The possibilities are endless.

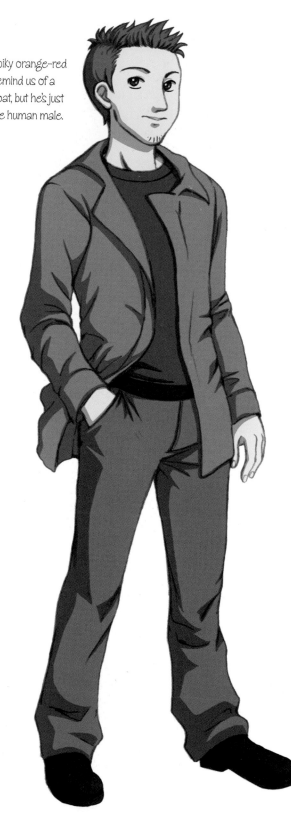

### Human

This man's spiky orange-red hair might remind us of a fox's furry coat, but he's just your average human male.

## MOVING ALONG

Different animals have different gaits, and they all have special terms. Here's a brief overview of the ones you'll encounter throughout the book.

**Bipeds:** Something that moves on two feet. Examples: humans and birds.

**Quadrupeds:** Something that moves on four feet. Examples: cats, dogs and horses.

**Plantigrade:** Walking on the sole of the foot. Examples: humans and bears.

**Digitigrade:** Walking on toes. Examples: cats, dogs and birds.

**Unguligrade:** Walking on hooves. Examples: horses and goats.

## EMPHASIZE UNIQUE TRAITS

There are a number of ways to tackle anthropomorphizing. It helps to think about what physical traits the creature carries that make it stand out.

### Anthropomorphic Fox

Wearing clothes, walking upright on two legs, and sporting a wry smile and a head of hair, this anthro is arguably more human than fox. His fox features include his ears, muzzle, tail and digitigrade stance.

### Fantasy Fox

His body is undeniably foxlike, but a pair of eyebrows and a flexible mouth enable this fox to express his emotions in a uniquely human way. The expressive eyes give him a magical aura.

### Fox

This fox wears a neutral expression. There's nothing human about him, but we won't hold that against him.

# Artistic Style

Style is your individual approach to art, including the drawing and coloring techniques you use, and the elements you choose to express or emphasize in your work.

If you're just starting out, you may not have your own defined style yet. That's okay! Your style will develop naturally. As you practice drawing anthro characters, you'll discover the features you want to emphasize. It can be helpful to look at other artists' works for style ideas, but don't let that be your only source of inspiration. Work from real-life observation or photo references to learn the characteristics of your subject matter; this is essential to developing a unique style.

Let's take a look at some common stylistic approaches to drawing anthro characters. These examples use an impala as the base subject matter, but the results differ based on the approach.

## Get to Know Your Subject Matter

Study the characteristics of the animal you will anthropomorphize. Knowing your subject is always the first step, regardless of style. How can you draw an anthro impala if you don't know what an impala looks like? The impala has a short, chestnut-colored coat, tan to white on the underside, with black and white markings. It has a slender build with thin, graceful legs and a long neck. The males have S-shaped horns.

## Toon Style

This impala is reminiscent of characters in animation. His features are rounded and the details are sparse. The face is soft and stylized, capable of expressing a wide range of emotions; the eyes and ears are enlarged; and the horns are smooth instead of ridged. He has the impala's signature coloration, but like the other aspects of this design, the markings are greatly simplified.

## Realistic Style

This example focuses on capturing the nuances of the animal's likeness. The face, long neck, skinny legs and fur markings are proportionally faithful to the impala. While he sports a man's torso and arms, his lower body closely follows impala anatomy.

## Semi-Realistic Style

In this example, the features are somewhat realistic, but focused more on bringing in human qualities than accurately portraying an impala. The head is larger and the neck shorter, like a human's. The face has thoughtful eyes, eyebrows and a flexible mouth, allowing for human expressiveness. The ears and eyes are enlarged. The hair on the top of his head is longer and styled like human hair. The legs are impala-inspired, but the lower leg is shortened, giving it a feel of a human foot, albeit with a hoof.

# Drawing Basics: Human Anatomy

Because the human figure often provides the foundation in anthropomorphic art, it helps to have an understanding of human anatomy before jumping into drawing anthropomorphic characters.

Human bodies come in many shapes and sizes, but the following proportional details apply to all:

- The elbows align at about the waist.
- The wrists align with the groin area.
- The hips mark the halfway point on the figure.

### Basic Building Blocks

Practice drawing basic shapes and sweeping lines. Sketch lightly and quickly to create flowing and organic-looking lines. Once you have circles and ovals down, try connecting shapes to create 3-D forms.

### Ready, Set, Action!

Artists use a *line of action*, an imaginary line that is drawn prior to the figure, to establish the main direction of action. It's helpful for inspiring strong, dynamic poses. The line of action sometimes follows the character's spine, but not always. Think of it more as a force guiding the action of the character, rather than part of the figure.

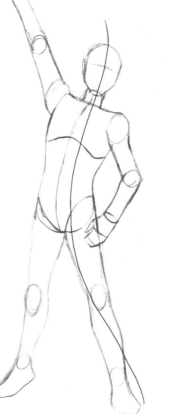

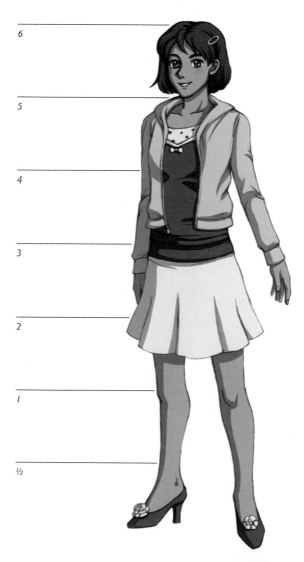

6

5

4

3

2

1

½

### Staying in Proportion

In art, body proportions are measured using a head to body ratio. In general, adults are about 7 to 7½ heads (8 heads if they are especially tall), teens are 6 to 6½ heads, children are 4 to 5, and babies are 3 heads tall. It's worth noting that the torso on the adult figure is about 3 heads tall. Keep in mind that these are just averages.

# Gender Differences

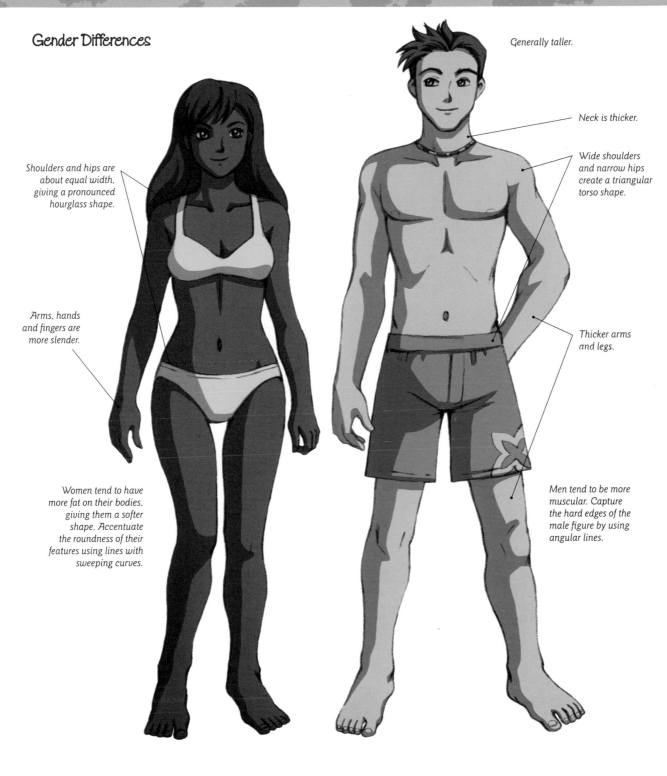

*Generally taller.*

*Neck is thicker.*

*Wide shoulders and narrow hips create a triangular torso shape.*

*Shoulders and hips are about equal width, giving a pronounced hourglass shape.*

*Arms, hands and fingers are more slender.*

*Thicker arms and legs.*

*Women tend to have more fat on their bodies, giving them a softer shape. Accentuate the roundness of their features using lines with sweeping curves.*

*Men tend to be more muscular. Capture the hard edges of the male figure by using angular lines.*

## Gender Differences in Animals

Many animals also display differences between genders. Variations occur in size and color, and the presence or lack of horns, feathers, antlers or tusks. For example, in many birds, like the cardinals shown here, the plumage of the male (left) is more vividly colored. Study your animal subjects and incorporate these details into your anthro characters for greater realism.

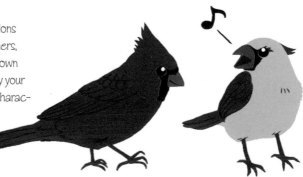

# CHAPTER I

# Felines

From the anthropomorphized cats of cartoons to the mostly human cat girls (and boys) pervasive in anime, feline furries are as prevalent in art and animation as real cats are in real life. Maybe their popularity is because of their generally friendly personalities or their graceful physical traits such as their forward-looking faces and large bright eyes. Whatever it is, from feared and respected feral hunters to domestic purr-piles, cats often enjoy a place on human pedestals, making them subjects of obsession or even worship. With so much to admire about cats (musical meows, triangular ears, rasping tongues, springing bodies), is it any wonder that artists enjoy mixing feline traits with our own human qualities?

In this chapter, we'll go over basics of furry "cat-natomy," ranging from the traits of small cats that fit in your hands, to large cats that could easily fit both your hands in their gaping mouths. Read along and learn how to make your own cat-tastic furry characters.

Cats at the Mall
by Jared Hodges
8½" × 12" (22cm × 30cm)

# Face

The domestic cat comes in many types and colors, but the key features that will help you transform a human face into an anthropomorphized feline face are the cat's glowing eyes, small ball-like muzzle and pointy ears. Emphasize these striking details as you draw your cat girl's face.

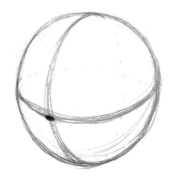

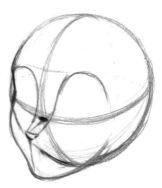

## EYE TIP

Cat eyes are large and built for nocturnal hunting. Domestic cats have eyes that form into tight slits in bright light, but open wide and round in dim light. Large cats' pupils are always round. Since your character is only part cat, you can use these eyes or standard human eyes, depending on which animal aspects you want to express in your anthros.

### 1 Start With a Circle
Draw a circle. (Don't go searching for a compass just yet—your circle doesn't have to be perfect.) Next, draw a vertical *guideline* across the curvature of the circle to bisect the head. Then, draw a horizontal guideline across the face. The crosshairs show the direction the face is aimed.

### 2 Form the Muzzle
Draw a small line out from the crosshairs, then draw the cat's triangular nose at the end of this line. Draw a guideline down from the bottom of the nose and place the chin. Build the brow line by pulling a pair of curved lines from the sides of the nose back into the face.

### 3 Sketch the Ears, Eyes and Mouth
Draw the eyes along the horizontal guideline. Make sure they are centered under the brow's arches. Pull down a pair of U-shaped lines from the base of the nose to create the mouth. Then, draw the cat's large triangular ears from the upper middle portion of the head. It helps to draw a guideline from the tip of the ears to align them.

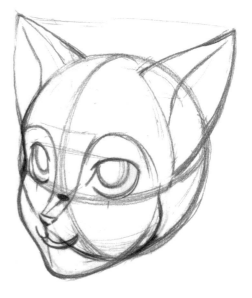

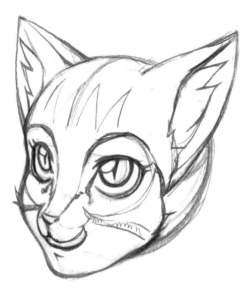

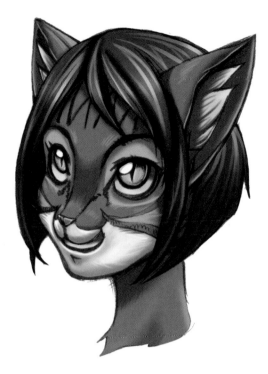

### 4 Add Fur Patterns and Details

Erase the guidelines and start drawing the facial details. Darken the lines around the eyes and mouth to help define those important areas. Next, draw in the fur patterns if desired. Since patterns can be complicated, use a cat photo for reference, or, if you prefer, just make up our own unique pattern. Magical Kitty!

### 5 Add Hair and Color

Give your character even more style by sketching in some hair. Remember to structure the hair around the ears, otherwise it'll make the ears look two-dimensional. Finally, color your character. Use photos or live cat models for reference. Stick with standard colors, or be creative, but remember, a green cat with blue hair might require some explanation.

## DRAWING FELINE EYES

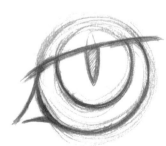

### 1 Create the Basic Eye Shape

Start with a circle. Draw a horizontal line across the circle for the eyelid. On the side of the eye closest to the nose, draw a line diagonally away from the circle to create the inner corner of the eyelid. Darken the portion of the circle below the eyelid to define the visible eyeball.

### 2 Draw the Iris and Pupil

Join the inner corner of the eyelid to the eyeball with a line. Draw a circle for the iris. Normally a cat's iris fills the entire eye socket, but since this an anthro cat, you can incorporate human characteristics by showing some white sclera around the iris. Draw the pupil (slit or round) in the center of the iris.

### 3 Add Detail and Color

Erase construction lines and add details around the eye, even eyelashes if you like. Then add color. Cats typically have blue, green or gold eyes. Cat eyes are also very reflective, so let them shine!

# Full Body

As you draw your cat girl, keep in mind the sleek looks, compactness and amazing abilities of a springy house cat, and adjust the basic human anatomy accordingly. Since this cat girl is still an adolescent (not a kitten, but not quite a cat), she's about 6 heads tall instead of the more adult 7 to 8 heads.

## CLOTHING TIP

Unless you want your character's clothes to be "fur tight," draw them hanging slightly off the body. Don't forget to add some lines to indicate wrinkles and folds, especially around joints, where fabric tends to bunch.

### 1 Sketch the Basic Body Shape
Start with a curvaceous line of action (see page 10) to give the cat girl a lot of spring. Next, draw the circle for the character's head with accompanying crosshairs. Roughly following the line of action down from the head, draw in the character's neck and three torso segments. Draw a guideline down the middle of the body (it's helpful for symmetry).

### 2 Draw the Limbs and Tail
Draw the tail at the base of the spine. Then draw the limbs out of the circular joints on the chest and pelvis. Because the cat girl is slightly turned, the joints on her left side are hidden from view. To approximate the position of these hidden joints, draw guidelines through the body. If it helps you to visualize, draw the limb segments that the body overlaps, and clean it up later.

**3** **Clean Up the Figure and Draw the Face**
Following the body's contours, refine the lines. Erase construction lines as you go. Fill in the details that won't be covered by clothes, such as the fingers. Since she will be wearing shoes, leave her feet as blocks. Next draw the face. To give her a devious sneer, drop her eyebrows and tighten her triangle mouth. Who knew she was a bad kitty?

**4** **Draw the Hair and Clothes**
Finish drawing the hair and remaining facial details. Draw her clothing following the body lines established in step 3. For the shoes, follow the shape of the foot blocks, point the toes and add some heels.

**5** **Color the Kitty**
Since you're creating a furry character, consider fur patterns and colors as well as flesh. This cat's simple tabby pattern consists of three main colors: orange-brown fur, a bit of white around the face and some dark stripes scattered across her pelt.

# Feline Features

Now that you're on your way to drawing your own feline anthro characters, here are some tips and suggestions for customizing your drawings with different types of tails, paws and patterns.

## PAWS AND CLAWS

Cats normally have four stubby fingers along with a thumb pad high up the front paws and no thumb on their hind paws. How far you take the feline characteristics is up to you.

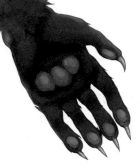

### Cat "Hand"

The structure of these hands is more human, but they incorporate fur, retractable claws and pads on each finger.

### Cat Paw

These hands are more rounded and pawlike.

**Leopard Pattern**

**Tiger Stripes**

**Cheetah Spots**

## FUR MARKINGS

Cats come in many patterns. Here are just a few of the different fur markings found on wild cats. For coloring, shade in the overall fur coat first, then work in the markings over the top. Nature is rough around the edges, so unless you want an intentionally simple or cartoony look, stay away from perfect circles and straight-line stripes.

### Create-A-Pattern

You don't have to base your character on a real cat species. Get creative with the colors and patterns to make all-new breeds. Green and blue with spots, stripes and swirls? Go for it!

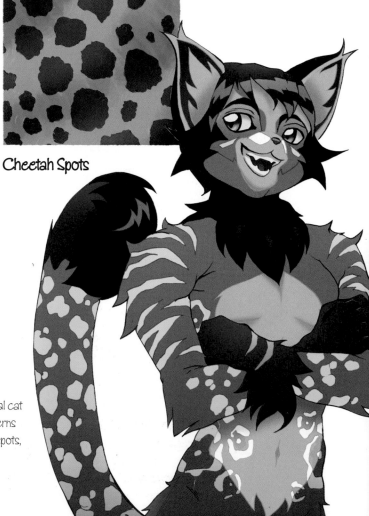

## DRAWING CAT TAILS

Drawing the tail is straightforward, though it can also be curved. It's all about the patterning, fluff and body language.

## TAIL EMOTIONS

You can show a lot about how your feline is feeling through his tail. Here are a few examples to get you started.

### 1 Draw a Simple Outline

Start with a basic tube shape, giving the tail the sweep and curvature you want. Pay attention to length. If it's too long you can always snip off a bit. Me-ouch!

### 2 Add Fur and Patterns

Draw long or short hairs (depending on the type of cat) to fluff out the tail. Clean up the lines and draw the patterning on the tail (leopard patterns in this case). The tail is a curved object, so bend the patterns around the tail. Don't draw them flat.

### A Little Bit Shy

A tail up in the air means he's in a good mood, but a hook at the end suggests some reluctance.

### Ready for a Fight

Watch out! Bristled fur along with a puffed tail means that he's frightened or angry.

### Not in the Mood

If he's violently thrashing his tail back and forth, it means he's irritated.

### Connecting the Tail to the Body

The tail connects to the body right about where the spine ends. A typical cat's tail extends an extra twenty vertebrae past where the human spine ends.

# Action Poses

Cats, with their natural flexibility, lend themselves well to action shots. It's easy to imagine them twisting and turning their limber bodies into dynamic feline-inspired poses.

## STALKING CAT

Cats are a natural fit for acts of covert espionage. They move stealthily through their surroundings, and their whiskers help them read air currents and ensure that they never try to wedge their bodies in too tight a place.

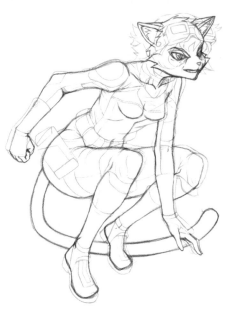

### 1 Create the Basic Pose
Block in the basic shapes. Keep her body compressed and stealthy, but ready to spring at a moment's notice. Curve the cat girl's tail forward so that she can balance.

### 2 Establish the Body Lines and Clothing Details
Draw the details of the body and face. Use the body as an understructure for the clothing. This kitty is wearing an armor-padded cat suit, so the outfit should tightly fit her body contours (aside from folds around the joints). Keep the design interesting by adding occasional details, such as clothing seams.

### 3 Add Color
Think about colors that match the animal's breed and, in this case, profession. This stealthy cat girl doesn't want to stand out, so color her cat suit in neutral tones such as dark greens. Color sections of the armor with alternating tones of gray-white and blue-black to break up the monochromatic green tones. Since this character is a Russian blue, short and sassy blue hair and gray-blue fur fits her feline breed.

## COUGAR ON THE BASKETBALL COURT

*It's not uncommon to see a cat casually jump six feet into the air. Large cats, like cougars, can jump even higher. With such amazing skills, cats could easily outleap players in any basketball league.*

### 1 Create the Basic Pose

This is a male cougar, so beef up his upper body, especially the arms, and slim down the hips. Big arms and a wide chest will make your character exude power. Use perspective and foreshortening to make the cougar spring out at the viewer. To create this effect, draw a *vanishing point* at the bottom of the image (see page 104). Draw guidelines down to the point to help align your character's body as it diminishes into the distance.

### 2 Add Details and Color

Give your cougar a jersey to make him the basketball superstar he wants to be. Look for natural guidelines in your picture as you draw his clothes. The line running down the sides of the jersey should also conform to the perspective point established at the bottom of the image. Then, add some color. As you work your way up the character, use a heavy gradation from dark to light to give him more visual pop.

# Feline Variations

Only superficial structural differences separate cat breeds. You can transform an average house cat into a wild lynx or any other cat with small adjustments to proportion, patterning and fur length.

Big cats, such as lions, tigers and leopards, have many of the same features as their small cat cousins. They are stocky and thick muscled, their noses and muzzles are larger and their eyes are positioned higher up on their heads. Despite their larger size, big cats have eyes and ears that are proportionately smaller than domestic cats. Whichever type of cat you draw, consider which feline traits you want to express.

## 2 Substitute Long Hair for Long Fur

Since Persians are a longhair breed, long luxurious locks of hair make a good substitute for feline fur.

## 1 Draw a Persian House Cat's Face

The Persian's trademark features are flat faces and fluffy coats. Keep the nose fairly close to the crosshairs, draw the eyes slightly below the crosshairs and spread the mouth wide across the face.

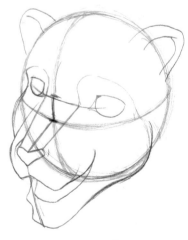

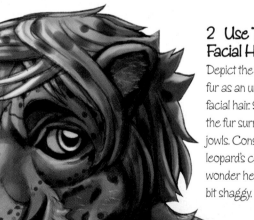

## 2 Use Thick Fur as Facial Hair

Depict the thick muzzle fur as an unkempt patch of facial hair. Simply spike out the fur surrounding the cat's jowls. Considering the snow leopard's cold habitat, it's no wonder he lets himself get a bit shaggy.

## 1 Make a Snow Leopard's Face

Extend a guideline from the crosshairs to place a heart-shaped nose. Then build the big-cat muzzle around the nose. Draw the eyeline a quarter of the distance from the crosshairs. The space between the eyes is slightly wider than the muzzle. Draw the ears proportionately smaller than those of a house cat.

## Lion—Dignified King of the Beasts

The male lion's mane encircles his face like a human hairline, running across the forehead, coming down around the front of the ears and spreading around the cheeks and neck. A characteristic unique to the lion, the heaping hair makes his already large head seem colossal.

## Cheetah—Built for Speed

Cheetahs are built for pure speed. Make your cheetah character stand apart by anthropomorphizing the cat's slender aerodynamic body, small waist and powerful long legs.

# Morphology

There's more than one approach to drawing anthropomorphic cats. A popular variation is to draw a human character with large triangular cat ears. You don't have to stop there. A tail, a cat nose and slight facial markings are points of interest that make the character unique.

Or you can go in the opposite direction and draw a feline character that's 90 percent cat and 10 percent human. That is, start with a cat body and add some human qualities, such as hair, clothing and facial expression.

## STRAY CAT BOY

### 1 Draw a Quick Preliminary Sketch
Quick sketches help you visualize the image without struggling over the details. Draw fast and keep your sketches small. Don't make the drawing much more developed than a stick figure. When you find the sketch you like, use it as the basis for your character art.

### 2 Draw the Body Framework
Draw a lean character, with some definition to his frame. Keep his body narrow and angular. Don't overmuscle him or he'll look like a cat man rather than a cat boy. Keep his stance rigid and weight evenly divided between his legs.

### 3 Finish the Drawing
There doesn't have to be a hard line distinguishing the fur on the head from fur on the ears. The cat ears can form right out of the hair on his head. A solemn expression and sparse clothing complete the stray cat look.

## TOUGH AND TUMBLE FANTASY CAT

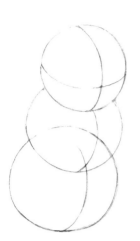 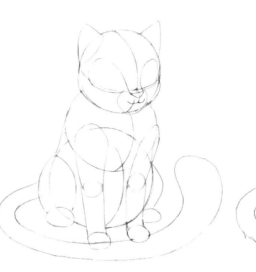

### 1 Start With the Basic Shape
Sketch a circle for the head with crosshairs to position the face and eyes. Add two more circles to create the general shape of the body. Then, draw a guideline down the middle of each circle to align the upper and lower torso with the head. At this point your fantasy cat looks a bit like a snowman—that's okay!

### 2 Build the Body
Add legs, slightly overlapping the feet for an extra sense of dimension. Then, draw a long tube for the tail. Increase the size of the tail toward the tip so it looks like it's coming out at the viewer. Fill out the face with the general shape of the ears, muzzle, brow and cheeks.

### 3 Develop the Details
Place the eyes along the horizontal line on the face. To give your fantasy cat a devious look, slant the eyes inward and drop the eyelids slightly. Even though the eyes are partially closed, it helps to draw the whole pupil to get the right shape. Use sharp, angular pencil strokes for his fur and hair to give him a rough-around-the-edges look. Draw the bandage with a slight arc to match the curvature of his tail.

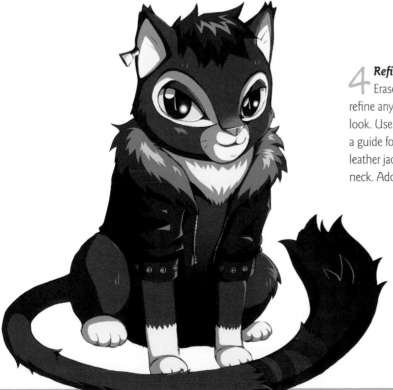

### 4 Refine and Add Color
Erase the construction lines, and refine any remaining rough lines for a clean look. Use the underlying body structure as a guide for drawing the shape of the cool leather jacket with fluffy fur around the neck. Add color to complete the picture.

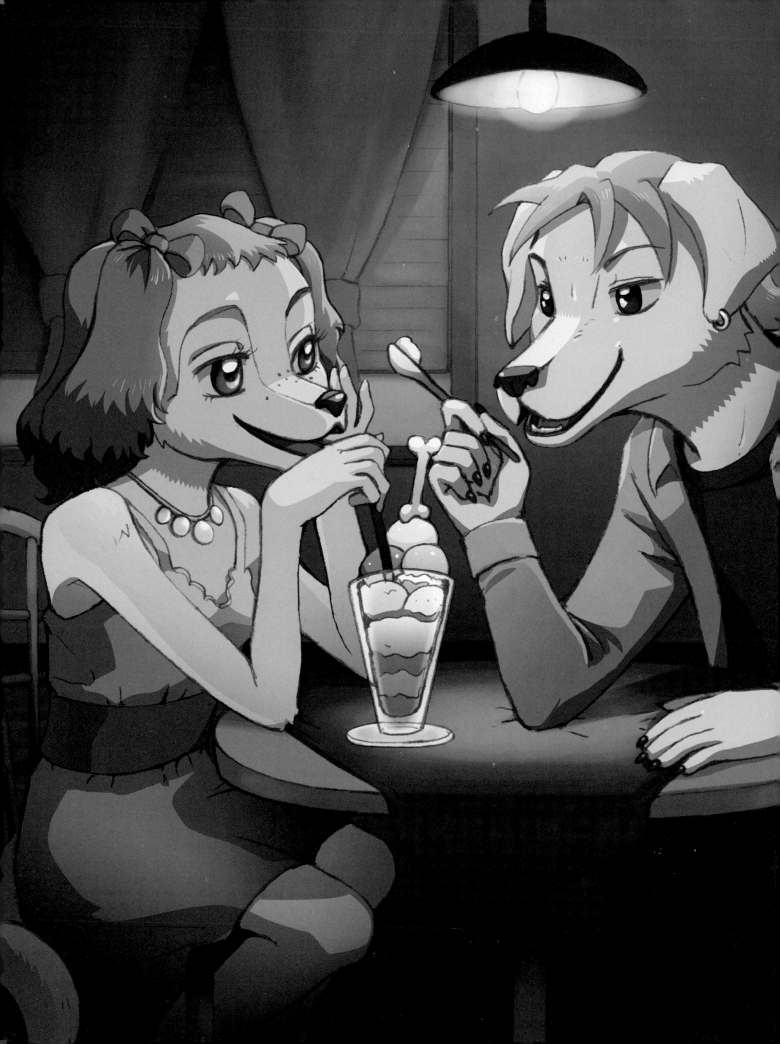

# Canines

Canines are one of the most popular animals depicted in furry art. They come in many forms, from the familiar domestic dog to feral foxes, wolves and more. Prominent the world over, members of the canine family fulfill a variety of roles, including companion and protector, sly pest and respected adversary. These carnivorous creatures of power and beauty range in shape and stature but are typically characterized by their long muzzles, slim bodies, fierce fangs and bushy tails.

While thousands of years of selective breeding have given rise to over four hundred recognized dog breeds, it hasn't succeeded in producing a single bipedal, talking dog. Meanwhile, furry fanatics and anthro artists create these creatures all the time—on paper anyway.

With over thirty canine species, it wouldn't be possible to cover them all in a single chapter. Fortunately, no matter how varied canines come, they all share similar traits. By learning a handful of key features, you can recreate any type of canine as a furry, or even make your own unique hybrid. So, unleash the beast and let loose the hounds—it's doggy time.

**Doggy Date**
by Lindsay Cibos
6½" × 7" (17cm × 18cm)

# Face

One thing that's common among most canines (including wolves and foxes) is a long muzzle. Mastering the muzzle is fundamental for drawing canine characters and provides a foundation for drawing other furry, feathery and scaly characters as well.

In this demo, you'll try your hand at a beagle puppy. Puppies have stubbier snouts than adult dogs. Keep the round and cute qualities of a puppy in mind as you draw.

## THINK IN SHAPES

Imagine the muzzle as a 3-D cone or hexagon shape attached to the lower front of the character's head. Obviously, a dog's muzzle isn't nearly as angular as a hard-edged hexagon or as tubular as a cone, but it's helpful to think in these terms. Once you have the basic shape in place, sculpt it into a natural-looking muzzle.

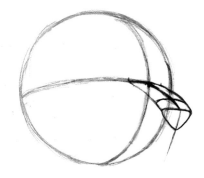

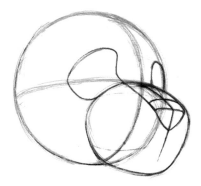

### 1 Draw a Circle and Start the Muzzle
Sketch a circle and place crosshairs for the face. Draw a curved, downward sloping guideline out of the crosshairs and place a wide triangle nose at the end of it. From the ends of the nose pull two lines back to the circle to form the bridge of the nose. Add a line across the snout, slightly behind the nose triangle, for a 3-D look. Indicate the front of the snout by drawing a guideline down from the center of the nose.

### 2 Shape the Muzzle and Brow
For the beagle's bulbous muzzle, start where the bridge of the nose meets the head and draw a round shape protruding from the front of the face. Build the brow by continuing the lines from the upper part of the muzzle around the face, then connecting them back into the muzzle. A beagle normally has a droopy brow. It starts high and sags into his cheeks.

### 3 Draw the Eyes, Mouth and Ears
Draw the eyes centered beneath the brow, along the horizontal crosshair. Create the beagle's upper lip with a W-shaped line. Give the upper lip a bit of droopiness in the front and gradually pull it upwards as it gets closer to the face. The lower jaw tucks under the upper lip, so don't make it too wide. Draw the beagle's floppy ears, starting a little behind the top of the brow.

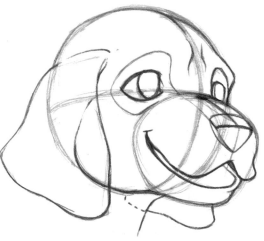

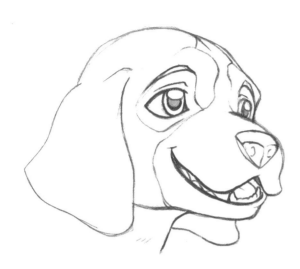

### 4 Detail the Drawing
Draw the pupils, highlights and other fun details to finish the eyes. Add eyelid folds above the eyes, then some eyebrows at the top of the brow line. Define the nose, drawing in a pair of nostrils. Add mouth details, including fangs and a tongue. Finally, erase any guidelines and sketch the beagle's fur patterns.

### 5 Add Hair and Color
Give the character a spiky hairdo that matches his playful "fur-sonality." Remember to draw hair on top of the head and behind the ears. As you color, emphasize the highlights on wet objects like the eyes, nose and tongue to make them glisten.

## DRAWING CANINE EYES

### 1 Create the Basic Eye Shape
Start with a circle for the eyeball. Draw a curved line horizontally across the eye to create the eyelid. Give the eyelid a broad upward sweep towards the nose, then let it gradually droop as it pulls toward the outside of the face.

### 2 Draw the Iris and Pupil
Draw a line to join the inside corner of the eyeball to the eyelid. Draw a series of large circles, one inside the other, for the iris and pupil. Dogs have large pupils, so don't be afraid to let the pupil fill a big chunk of the eyeball. Place these circles slightly beneath the upper eyelid.

### 3 Add Finishing Touches and Color
Thicken the eyelid rim with a second, darker outline. Then, draw a line indicating a fold above the upper eyelid. After you finish adding small details like lashes, clean up your drawing, and erase any construction lines. Beagles typically have brown eyes with black eyelid rims.

29

# Full Body

Canines communicate their feelings through body language and facial expressions. The beagle is a friendly and sociable breed, so give him a strong pose that expresses these personality traits.

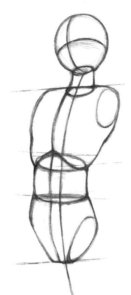

## 1 Sketch in the Basic Body Shape
Start with a line of action (see page 10) to establish the general positioning, and give your character a confident, upright pose. Then, draw a circle with crosshairs for the head. Next, develop the torso shape. Try to keep the centerline of the figure aligned as you work down the body.

## 2 Draw the Limbs, Tail and Face
Develop the basic details of his head, including the muzzle, brow and ears. Draw the limbs. Overlapping arms are a bit tricky. Take it one step at a time: first draw his right arm hugging his torso, then his left arm (grabbing his other arm above the elbow) over the top. Then, draw his thin, upright, beagle tail.

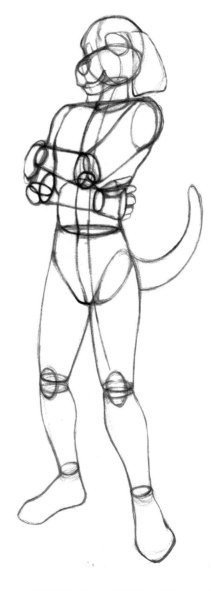

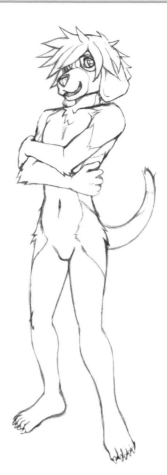

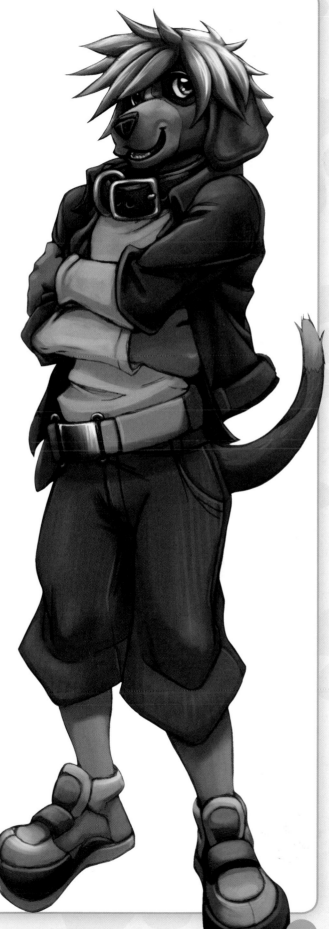

### 3 Define the Body Contours

Clean up and define the character's body structure. If you intend to cover up your character with clothes, as in the next step, you don't need to detail the anatomy (as we did here with fur and claws). Beagle coats have several distinctly colored sections. Lightly sketch the major fur pattern divisions before complicating the design with clothes and props.

### 4 Sketch the Clothes

Sketch the character's clothes, starting with the most prominent articles. Draw the jacket, then the visible portions of his undershirt; then move on to the pants and shoes. As with the body, develop the clothes with a basic structure to make sure everything works before adding details. Erase the hidden body lines as you go.

### 5 Add Details and Color

Add a belt and a dog collar. Define the wrinkles in the clothes and draw structural details like pants pockets and seam stitching. Then, color. Use bright highlights on the belt and collar buckle to bring out their metallic qualities. Use muted colors on his jacket, pants and shirt to draw attention to his colorful shoes and matching collar. Or try your own color combinations.

# Canine Features

Tail, paw and teeth styles are the nitty-gritty details that define anthro canines. Understanding how they work will take you a long way in creating believable dog, wolf and fox characters.

## CANINE TAILS

Canine tails come in a wide variety, including short and stumpy, curled and bushy, and long and whiplike. Wolves have a torpedo-shaped tail, bristling with fur.

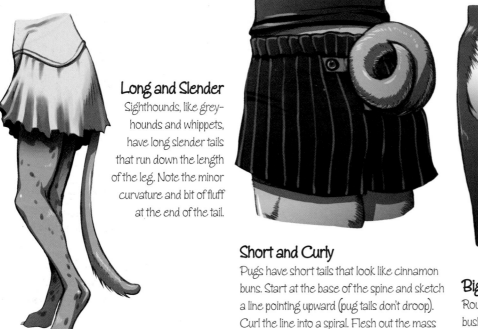

### Long and Slender
Sighthounds, like grey-hounds and whippets, have long slender tails that run down the length of the leg. Note the minor curvature and bit of fluff at the end of the tail.

### Short and Curly
Pugs have short tails that look like cinnamon buns. Start at the base of the spine and sketch a line pointing upward (pug tails don't droop). Curl the line into a spiral. Flesh out the mass of the tail. Indicate fur texture with highlight flecks.

### Big and Bushy
Rough collies have extremely long hair and bushy tails. Build it up like a wolf tail but with more fur mass. Emphasize long-haired dog qualities on your anthro character by adding extra fur on the body.

## DRAWING A WOLF TAIL

### 1 Start With a Basic Line
Sketch a line out from the lower back to define the arc and direction of the tail. A wolf's tail measures about half the length of its upper body.

### 2 Sketch the Basic Shape
Sketch the shape of the tail around the line. As you form the shape, make it puffiest towards the middle and gradually taper the tail at the ends.

### 3 Add Fur and Patterns
Draw the fur and pattern details. Keep the tail's conical shape in mind as you fluff it out. If you lengthen the tail and change the patterning, you can turn the wolf tail into a fox tail.

## PAWS AND CLAWS

Like many animals, dogs walk digitigrade, bearing all of their weight on their toes. Depict this feature in your upright-standing furries by drawing canine rear paws for the lower segment of the character's leg.

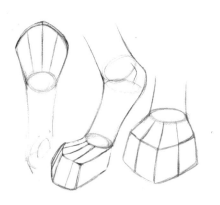
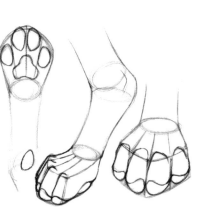
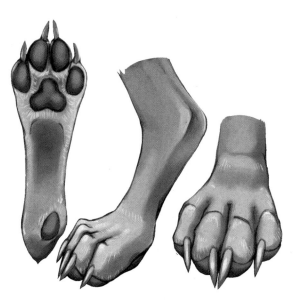

### 1 Draw the Basic Shape and Toes

Sketch a basic pentagon shape for the paw. Pull a tube shape out of the top of the paw to form the canine foot. Like standing on tippy-toes, the length of the actual foot is suspended in the air. This section ends in the heel and ankle before continuing into the lower leg.

Divide the paw into four even slices. To achieve evenly spaced toes, start with the centerline and work out from there.

### 2 Add Pads and Develop Shape

The pads provide traction and shock absorption. Draw one pad for each toe, a central pad and one more at the end of the heel.

### 3 Add Claws and Color

Draw a claw for each toe. With the exception of foxes, canine claws are nonretractable. Each claw sits on the inner part of the toe; note the closeness of the two central claws. Finally, color according to the dog breed you're drawing, or use your imagination. Add some texture to the pads to give them a worn, walked-upon look.

## SHOW OFF THOSE CANINES

The term *canines* defines a principal feature among these animals, namely their large fangs. In the wild, animals use these fangs for grasping, puncturing and latching onto a meal. In your artwork, fangs can enhance everything from a character's cute smile to a ferocious snarl.

### Scissor Bite

Dogs have an average of forty-two teeth, but no one expects you to draw all of them. This husky dog demonstrates how you can get away with drawing just a handful of teeth and still get the point across. Note how the teeth interlock when the mouth is closed.

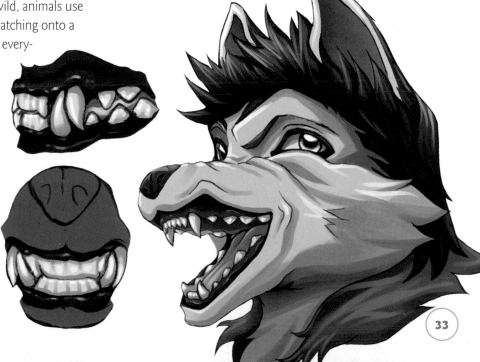

# Action Poses

*Think about the types of activities that dogs enjoy doing and find ways of humanizing them.*

## WHIPPET PHOTOJOURNALIST CAPTURES THE SHOT

*Like a canine equivalent of the cheetah, sighthounds are streamlined hunters specializing in sprinting and agility. Relying on visual acuity for high-speed tracking, these long-muzzled dogs have specialized eyes that give them a wide field of excellent vision. This photojournalist uses her breed-specific gifts to chase down the perfect photo with ease.*

### 1 Sketch the Body Frame
Block in the basic shape of the figure. Try to capture the whippet's physical qualities in your drawing, such as a strong chest cavity that tapers into a narrow waist and strong legs. Use guidelines to help you block in the geometric shape of the camera.

### 2 Add Details and Color
Work up the details of the figure (don't forget the claws). Complete the drawing with an outfit suitable for a professional photojournalist. Add small details like the camera strap, earring and watch for extra pizzazz. Finally, clean up the construction lines and your "on point" dog girl is ready to color. Whippets come in a variety of colors and patterns. Use a second color pattern on her feet to suggest shoes.

## PUPPIES AT PLAY

*Puppies love to play. Hold out a toy or rope to a puppy, and it'll latch on and tug. This activity lends itself well to the similar child's game of tug of war.*

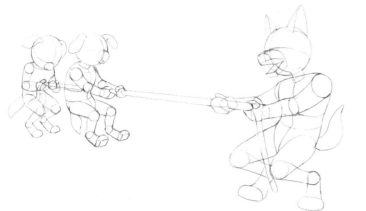
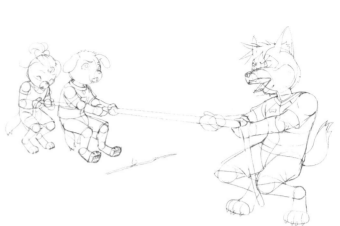

### 1 Block the Basic Shapes

Build up the figures, taking care to depict them throwing their weight into the game. Strengthen the poses with secondary actions, such as feet digging into the ground, a head bowed in concentration and an open-mouthed yell. Use *two-point perspective* (see pages 114–115) to align the puppies with each other and the rope.

### 2 Fill In the Details

Start drawing the hair, hands, feet and clothing on each of the characters. T-shirts and pants hang loosely on the body, so give the clothes volume and folds as they conform to the figures. Then, fill in the facial features. Use expressions that harmonize with the characters' poses. Draw a pair of upturned eyebrows and an open mouth on the middle pup to give him a worried look. Draw a stick on the ground to indicate which side is winning.

### 3 Clean Up the Drawing and Add Color

Erase the guidelines as you finalize the details. Then, add some color to the characters. In lieu of a fully realized background, render a hint of environment around the characters' feet. Give the ground volume by working in shadows and highlights. Use darker shadows where the characters are standing.

# Canine Variations

Canines come in a lot of shapes and sizes. Muzzles can be short or long. Body types range from tall and muscular to tiny and cute. Patterns and colors greatly differ between species and breeds. Even two dogs of the same breed can look very different. Study and pull inspiration from real-life canines to add variation to your anthro characters.

## GRAY WOLF

### 1 Sketch the Basic Shape

Start with a circle and crosshairs, then pull out the muzzle. The wolf's sharp features give it an air of danger and majesty. Keep this in mind as you draw the basic shape of the ears and eyes. Add some angular fur ruffs on its cheeks—viewed from the front, the wolf's head (minus the ears) looks pyramid shaped.

### 2 Add Details, Patterns and Mane

Fill in the eyes with large, dark pupils for a piercing gaze. Sketch in the fur patterns. Use guidelines to keep the design on both sides of the face symmetrical. Build up her thick multilayered coat with a coarse mane (the collar of fur ringing the neck).

### 3 Add Hair and Color

Humanize your anthro wolf with a head of hair. Sharp, angular locks enhance her standoffish look. Gray wolves can of course be gray, but their fur also comes in white, red and black variations. Wolf eyes have almost no visible sclera; suggest this by keeping the eye area darkly colored.

## Yorkshire Terrier—Compact Glamour

Yorkies are a breed of toy terriers with tiny bodies hidden beneath a sprawling coat of shimmering long fur. If you want to stay true to the compactness of the breed, reduce the character's proportions to roughly 3 heads high: one segment for the head, one for the torso and one for the legs.

## DALMATIAN

### 1 Sketch the Basic Shape

Start with a circle. This character is tilting his head upwards, so draw the crosshairs high on the circle. As you build up the muzzle, eyes and ears, maintain rounded edges. Give him a smile and a bandana to complement his playful, energetic nature.

### 2 Add Hair, Details and Color

Refine your drawing with details like spiky hair and inquisitive eyes. Clean up the construction lines, then add some hatched lines to give the pup some texture. Don't forget to add spots! Consider turning the spots into familiar shapes, like stars or hearts, for a fun twist.

### Boxer—Big Softie

This boxer has an extraordinarily broad chest and arms three times the diameter of the beagle depicted on pages 30–31. Creating bulky characters, from boxers to baboons, starts by enlarging and deforming the basic anatomy blocks. Sketch the bulked-up body framework, then sculpt the major muscles using reference from anatomy books or bodybuilder photos. A word of caution: Drawing a muscular character doesn't require slavishly defining each muscle. Don't worry if the rectus femoris or the external abdominal obliques go underrepresented in your art. The goal is to create a strong-looking character, not an anatomy chart.

*Yorkshire Terrier Size Comparison*

# Morphology

Anthropomorphic art is all about what animal-specific features you want to include, and the degree to which those features are expressed.

## HUMAN WITH CANINE FEATURES

*Humans with dog features but no muzzle lose a lot of what makes them stand out as ostensively canine. You can make a character look bestial by placing nondescript canine features, like fangs or a bushy tail, on a human frame, but to give the character an even more canine look, sprinkle the features of a distinctive species or breed into the design. In the case of this dog girl, blend in traits from the papillon dog breed, including large butterfly-like ears, a fluffy tail and patches of silky fur on the limbs.*

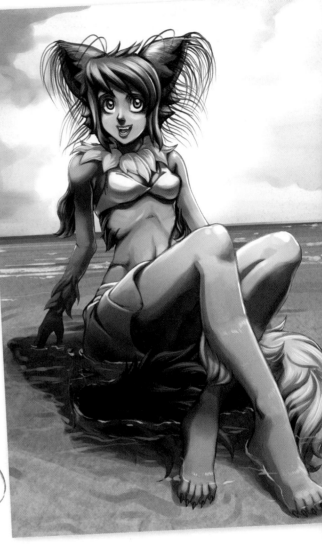

### 1 Sketch the Human Form
Sketch the head and line of action to define the dog girl's face and posture. Rough in her leaning body with basic anatomic shapes. Give the image depth and dynamism by enlarging the legs and feet as they come out towards the foreground and diminishing the arm placed farther back behind the body.

### 2 Add the Canine Features
Finalize the human facial features and sketch large butterfly-wing ears. Blend the overall shape of the ears and their fringe into hair. Add small patches of fur across the body sparingly on the backside of arms and legs to augment the human anatomy without overwhelming it. Sketch the tail snaking around the body and connecting to the line of action. Draw standard toes on the feet, but cap them with canine nails. Woof!

### 3 Add Details and Color
Finish the drawing with tail fur and a simple swimsuit. Use colors to define regions such as the lower arms and legs as fur covered. Fleck bright highlights over the base fur tone to make the fur shimmer. Paint quick, loose strokes of color to plume the fur around the ears and tail, completing the papillon look. Color in a background so your character can recline at the beach.

## FANTASY CANINE

*A corgi is an exuberant little dog with short legs and foxlike features. Try to capture his gleeful, loving personality in your drawing. A Pembroke Welsh corgi typically has a very short tail, but because this is a magical fantasy dog (with wings!), you can make your corgi's tail as long or as short as you want. If floating wings aren't your thing, you can always attach them to the shoulder blades or leave them out entirely.*

### 1 Start With the Basic Shape

Draw a circle with a pair of crosshairs for the head. Add a second, slightly larger circle beneath that one for the chest. Draw a third, smaller circle for the hindquarters. The smaller final circle helps give the illusion that the corgi's body is receding as he walks towards you.

### 2 Build the Body

Extend the muzzle. A dog's open mouth is a tricky shape, so use guidelines to line up the upper and lower jaws. Draw the general shape of the brow line, ears, tail and wings. A lifted paw adds to the corgi's playful body language. To firmly plant the remaining three legs, sketch a rectangle the width and length of the dog, and draw each foot touching a corner of the box.

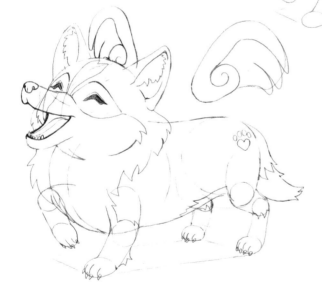

### 3 Draw the Fur and Details

Fluff up your fantasy corgi with some fur. Refer to a photo of a corgi for ideas, or invent your own fur patterns. A heart-shaped paw print on his side makes for a nice touch. Draw the rest of the corgi's details, including eyes, nose, teeth, tongue and paws. Fill in the free-floating wings with a fun, spiral-shaped design.

### 4 Add Details and Color

Erase the guidelines and clean up stray lines. Make final adjustments, add extra detail to the fur and you're done! Corgis come in red, black and tan, and sable varieties, but yours can be any color of the rainbow. Go wild!

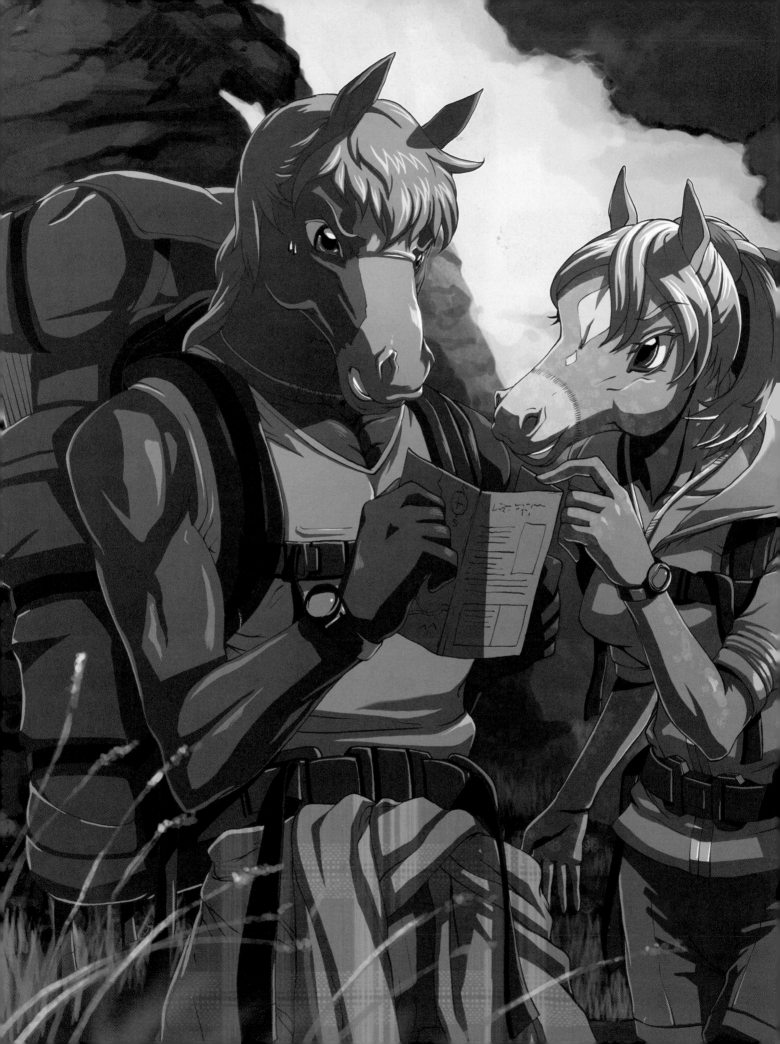

# Equines

Equines, a family of grass-grazing herbivores, which include horses, ponies, donkeys and zebras, are at home herding across wandering hills, vast plains and fertile fields throughout the world. Reputed for spirited legwork and flamboyant posturing, horses in particular are living symbols of speed, power and pride.

Equines exhibit a docile demeanor and physical characteristics often associated with beauty (muscled build, graceful necks, long legs and immense, lustrous eyes). Throughout history, humans have literally harnessed these powerful creatures for work, recreation and locomotion.

Although most of us rarely encounter horses and zebras, that doesn't change the sense of majesty we feel in their presence. Moreover, as our everyday connections fade, these ordinary animals take on an air of nostalgic fantasy, like creatures dwelling only in our dreams.

In this chapter, you'll learn to combine human and equine traits into a fantastical anthropomorphic creature of your own. So, mount a pencil in your hand and turn the page. On the road ahead lies a lesson in equine illustration.

**Lost on the Plains**
by Jared Hodges
11" × 13½" (28cm × 34cm)

# Face

Horses, with their very inhuman facial anatomy—long snouts and curving necks—can be tricky to convert into anthro characters. It's perfectly valid to draw a realistic horse head atop a human body. However, the approach we recommend is to soften the slope of the snout and exchange the neck of a horse with a more humanlike neck that sits beneath the head rather than emerging from behind it.

Try this anthro horse head. While she's a palomino with spunky feminine features, the steps remain relatively the same for all breeds.

### 1 Draw the Head and Snout Structure
Sketch a circle and curved guidelines. At the crosshairs, draw a guideline projecting straight out and a second one straight down. Draw a third guideline roughly bisecting the other two to represent the center of the down-angled snout. Cap this line to form an upside-down T shape, and pull the sides of the T back into the face, widening the snout until it reaches the horizontal guideline.

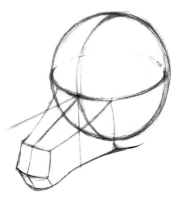

### 2 Shape the Snout
At the base of the snout, draw a line down slightly past the ball of the face. Build up the front of the snout with a series of lines, making it like a rounded arrowhead. At the center of the bulge, draw a curved line to start the lips. Sketch the chin slightly drooping before pulling it taut into the hanging guideline from the beginning of this step.

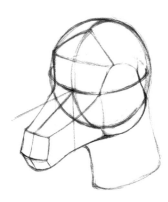

### 3 Shape the Face
Pull the lines at the base of the snout up and apart. Continue the right line back into the horizontal guideline to create the brow shape. Beneath the brow, form a large semicircle for the jaw, connecting the brow and snout. From the crest of the brows, sketch two lines converging to form a pentagon for the forehead. Pull lines for the neck from the front and back of the circular portion of the head.

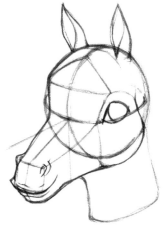

### 4 Place the Facial Features
Draw the eyes towards the front of the brow, along the horizontal guideline. At the top of the head, behind the eyes, draw a pair of leaf-shaped ears, and give them some depth. Add a pair of nostrils curved around the front of the snout. Draw the mouth a bit farther down the length of the snout.

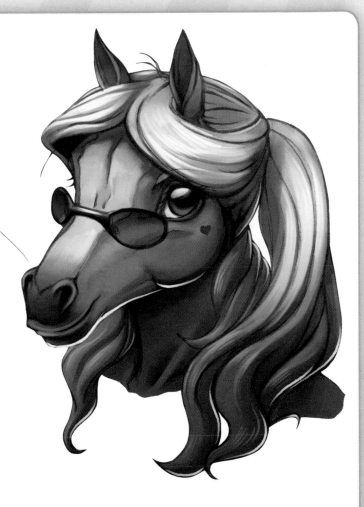

## 5 Detail the Face

Make a final pass over the face, detailing features and cleaning up unnecessary lines. Finish the eyes and add the eyebrows along the brow line. Draw a pattern (like this blaze pattern) to give the face additional structure and visual interest. Draw ridgelines on key areas across the face to solidify the facial structure.

## 6 Draw the Hair and Add Color

With a little imagination, transform a horse's mane into a playful human hairdo. Don't forget to draw the rest of the mane, running down the length of the neck. Pulling inspiration from the palomino's palette, color the horse with golden browns for the coat and shimmering yellows for the mane. A pair of pink-tinted spectacles and a little temp-tattoo gives this mare a fun-loving look. And, yes, that is lipstick on a horse.

## DRAWING EQUINE EYES

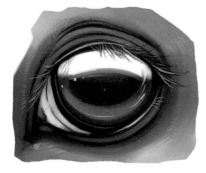

### 1 Create the Basic Eye Shape

Start with the almond-shaped eyelids. Between the eyelids, draw a large circle for the iris. Horses have the largest eyes of any land mammal. The iris should fill the majority of the eye socket.

### 2 Refine the Eye

Draw the wide semi-circular pupil in the center of the iris. Draw a second line around the edge of the iris to create a thin rim. Beneath the lower eyelid, draw a broken line, and then a second line under that. Draw a fold line above the top eyelid and hook a little bulge at the corner where the top and bottom eyelids meet.

### 3 Add the Finishing Touches and Color

Draw in any desired eyelashes or details to finish the drawing. Palominos usually have dark eyes, but why not break with convention and go with a bright blue? Color the eyelid a shade darker than the surrounding fur. A highlight on the edge of the lower eyelid makes the section look moist and helps the lid to appear over the eyeball. Horse eyes are very reflective, so add bright highlights dancing across the eye.

# Full Body

*Caught in midstride, this plains-dwelling mare bounds with the high-stepping energy and enthusiasm that saddlebred horses are known for.*

*Follow along to discover the steps to drawing billowing clothing dynamically rendered around a body in motion.*

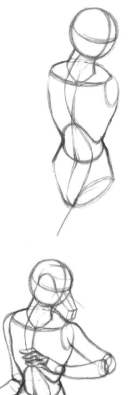

### 1 Sketch the Basic Body Shape

Sketch a line of action with a double twist. This will help you pull the character's head and body in different directions. Avoid overwrenching the bend between sections. Horses have bulky heads that require strong necks. As you draw the neck, make it as slender as possible while thick enough to reasonably sustain the head's weight.

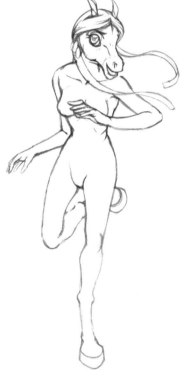

### 2 Draw the Limbs and Snout

Develop the basic structure of the snout. Then draw the limbs. The horse girl is halting her forward momentum, so her weight is on her left leg, while her right side is pivoting forward. Sketch the legs digitigrade style. Horses have knobby leg joints; bring out this key feature.

### 3 Clean Up the Body and Define the Face

Draw the face, detailing it to be almost finished. For the long braids of hair, start by drawing a flat ribbon that shows the general sweep of the hair. Erase the constructions lines, leaving only slightly more than a silhouette.

### 4 Sketch the Clothes

Every bodily sway or burst of air turns the dress fabric into a whirl of ripples and folds. To simplify the process, start by drawing the section of fabric anchored to the body. Then draw the twisting shape representing the open, loose end of the fabric. Connect the segments with lines that run the entire length of the dress.

### 5 Draw the Final Details

Work your way down the outfit, adding folds where arms bend, legs kick and the torso twists. Then, draw the details, such as stitching and beading inspired by Native American costumes. Where the overlying fabric covers the body, erase the figure lines. Finally, draw interweaving strands of braided hair into the ribbon placeholders.

### 6 Add Color

Color the character with a wash of warm earth tones. Use complementary cool blues and purples in the shadows to create a strong color contrast between areas of light and shadow. Color the front of the snout a lighter gray to denote thinning fur. Use several layered shades of color to create striation patterns in the hoof for a lacquered toenail finish.

# Equine Features

The most striking equine features include luxurious manes, long tails and hoofed feet. Before drawing, ask yourself: How do the legs bend? What do horse hooves actually look like? Where does the skeletal portion of the horse tail end and the hair begin? Understanding the characteristics of each feature will help you inject more horsey-ness into your anthro characters.

## THE MANE ATTRACTION

The horse's mane is a line of soft lustrous hair that streaks down from between the ears to the base of the neck. Hair from the mane lies relatively flat (unless her stylist disagrees), and, depending on the type of horse, is either straight or wavy.

### Forelocks

The forelock is a section of equine hair resembling human bangs. The locks fall forward from the top of the head directly between the ears. In some equines, the forelocks are short and spiky, while others have locks of hair that grow extremely long, covering much of the face.

### Plotting the Horse Hairline

There are several techniques for combining the human hairline and equine mane. One way (see above) is to seamlessly merge the mane with a human hairline. Another option involves dividing the two sections, one producing human hair, and the other a differently styled or colored equine mane. The final option is to grab an imaginary pair of clippers and do away with one section of hair altogether.

## EQUINE TAILS

Coarser and thicker than the mane hair, the horse's tail is a wonder of hair growth. Typically reaching down to the ankle, the hair can be cut or left to grow out to magnificent lengths. Style is important. Consider braiding or sculpting the hair with designer cuts.

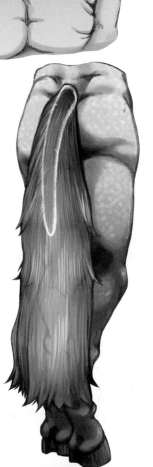

### Tail Bone

The actual fleshy portion of the horse's tail lies hidden beneath a curtain of hair and, despite its deceptively long appearance, extends only halfway down the length of the thigh.

### Tail Hair

When the tail is held aloft, you can see how the hair roots into the tail and grows consistently down its length.

## EQUINE LEGS

Plantigrades (humans, bears) walk on the whole foot; digitigrades (canines, felines) walk on the tips of their toes. Although the equine leg is configured similarly to a digitigrade leg, equines belong to a third group known as unguligrade or "hoof walking."

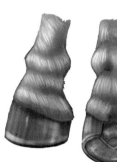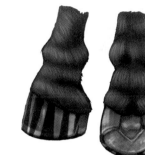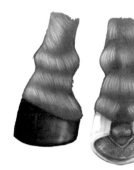

### All About the Hooves

The equine foot consists of one giant toe partially encircled by a thick protective toenail we call the hoof. Horse hooves come in a variety of colors—white, black, yellow or brown—and display gradations and even vertical stripes. It's also common for the same horse to have different colored hooves. Hooves have a forward slant and are longer in the front and dip in the rear. The back and bottom of the foot is unprotected by the hoof.

### Hoof Hands

Hooves don't allow for a character to grasp objects without great awkwardness. Here's a way to give the hands a hoof-inspired look without losing the functionality of human hands. Start with a normal hand, and cap each finger with thick, hoof-esque fingernails.

## STANDING TIPPY-TOE

When drawing horse anthros, there are a couple of different ways you can merge the anatomy of the horse leg with the human leg.

### The Anklebone's Connected to the ... Fetlock?

For this character, the upper section of the leg works like a human leg, while the lower section works like a horse leg. Note the compressed human lower leg that changes into a horse foot at the anklebone.

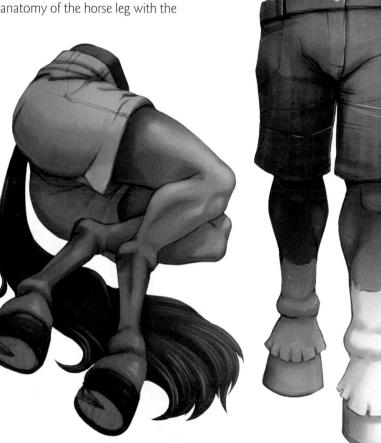

### Standing Tall and Proud

This character stands upright like a human. His legs work like human legs down to the feet where they transform into equine hooves.

# Action Poses

When drawing action poses for your equine characters, think about how to showcase their natural horse abilities. Horses are known for their endurance and strong legs, so consider poses involving legs in motion, such as a track runner or a dancing pony, like the one shown on page 49.

## CHARGING WARHORSE

*The goal of this action pose is to create a charging, armored medieval warhorse rushing onto the battlefield, flail swinging wildly in mid-attack. Armor is its own tricky beast to master, and this particular horse is wearing a full suit of it. There's no flexibility in plate armor. It's important that the rigid armor is properly articulated to allow for movement while completely encapsulating and protecting the wearer.*

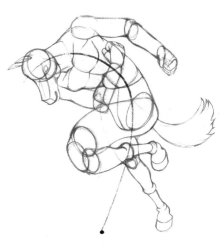

**1 Sketch the Basic Figure**
Start with a strongly curved line of action, contorting the body and neck into alignment. The center of gravity is slightly in front of the character, leaving his body slightly teetering off balance. This heightens the sense of motion. Draw one leg pushing off the ground with the other fully withdrawn to give further momentum to his pose. Sketch the tail streaking behind him.

**2 Draw the Armor**
Because armor is complicated, it's helpful to first sketch a draft with a light blue pencil. Draw the armor over the body, giving plenty of breathing room. This will bulk out the horse's frame, making even the most meager horse into a tank. Once you've worked out the kinks, go back over the blue lines with a graphite pencil. Clean up any unnecessary body lines.

**3 Add the Final Details and Color**
Sketch in the character's flail (or sword or axe if you prefer) and shield. Then you're ready to color your warhorse. The metallic portions of the flail and armor are highly reflective, so be sure to have them reflect the colors and the nature of the light and surrounding objects.

## DANCING SHETLAND PONY

*Horse action is all about the fancy legwork. While this anthropomorphized Shetland pony may have fewer legs than a standard horse, she's still able to strut, canter and trot the night away at a rave.*

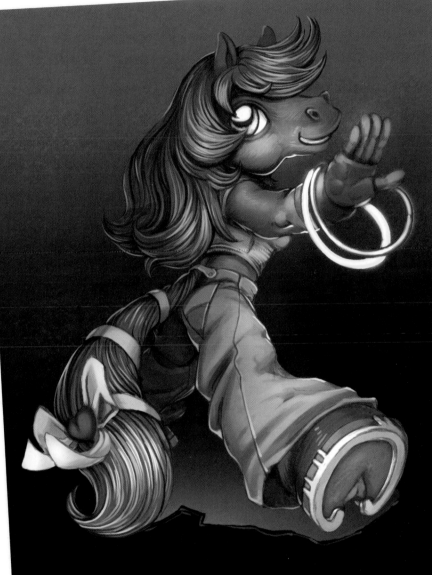

**1 Draw the Basic Figure**
Shetland ponies are short statured, so compress the body proportions into about 4 heads tall. Keep balance and stability in mind as you place the left leg. To make the horse girl's limbs fly out at the viewer, draw the figure in perspective to a *vanishing point* on the horizon (see page 104). Increase the body's size (right hand and leg) as it moves farther away from the vanishing point.

**2 Add Details and Color**
Detail the drawing with hair, raver clothing and accessories, including phat pants, a double-layer tank top, glow rings and a winding ribbon. As you add color, bring out the hardy Shetland's heavy fur coat with a multi-step approach. First, blend the highlights and shadow tones into a smooth basecoat. Then, define the coat by working additional strokes on top of the basecoat, with lighter tones in the highlights and darker tones in the shadows, following the fur grain. Four or five continuous strokes in one direction work well. The longer you make these strokes, the longer the fur tufts appear.

# Equine Variations

The equine family is made up of horses, ponies, donkeys and zebras. From body shape and build to coat coloration and patterns, there's a lot you can do to create variety.

Unicorns and Pegasus (a winged horse) also pull their inspiration from the horse; simply add horns or wings to transform your horses from magnificent to magical.

## UNICORN

### 1 Sketch the Basic Shape

Start with the basic circle and guidelines. This unicorn is a gentle princess, so modify the general horse face features to make her look dainty. Taper the snout's end and keep the neck thin and narrow. Don't forget the unicorn's key feature—its horn. Start with a small circle in the middle of the forehead, and pull two lines up to a rounded point.

### 2 Add Details to the Face and Color

Add the ears, nostrils and large, round eyes. Divide the spiral horn into equal curved sections. Add jewelry dangling from her horn and neck. Give her simple dress to keep the attention on her pretty face. Add a flowing mane of hair, and you're ready for color. White is traditional, but who's to say she couldn't be blue or lilac?

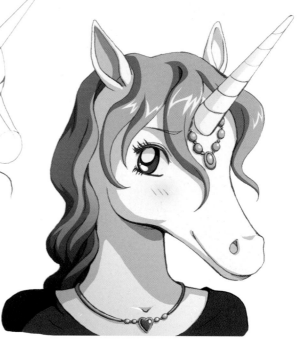

## ZEBRA

### 1 Sketch the Basic Shape

Zebras have stockier proportions than horses, making them anatomically closer to donkeys. Bulk up the snout and neck. Draw the ears slightly larger and rounder than a horse's. Sketch the overall shape of the zebra's stiff Mohawk, starting from the midpoint between the ears and tapering down the neck.

### 2 Add Details to the Face and Color

Divide the Mohawk into equal sections of jagged hair. Carefully pencil in the zebra's stripes (refer to photographic reference), keeping the stripes symmetrical on both sides of the face. The stripes should also correspond to the sections of the hair. Color the zebra with a striking palette of black and white.

## Pretty Pegasus

Perhaps it is because equines fly across fields and vault over obstacles that they are so often the recipients of wings. Wings have a way of accenting beauty and leaving a touch of the divine, transforming a stable horse into mystical Pegasus. Your Pegasus can be any breed and color (but white is the most common). This particular character is a Connemara pony, which has a compact body, a long neck and a dished head with a short face and small ears.

## NASAL NUANCES

There are a couple of different horse snout types. Aside from the standard straight snout, there's also the convex Roman nose (left) with a prominent bridge, typical of many draft horses, and the concave "dished" head (right) with a lot of curvature to the snout and an emphasized forehead.

## Shire Workhorse

If the job requires strength, draft horses like this shire are up for the task. Draft horses, with their muscular, sturdy bodies, are capable of pulling heavier loads than the average horse. Note the shire's Roman nose, which starts higher on the head and rounds outward. Starting midway down the arms and legs, long fur flares out, ending the limbs in a thick bell shape. Further enhance your heavy horse's build with strong legs and the shire's characteristic large feet.

# Morphology

A theme can help make your character stand out from the rest. Everything from symbols like stars and hearts to more complex ideas like holidays, seasons or feelings can be a source of inspiration.

## DRAWING A DELICIOUS, ICE-CREAM-THEMED FANTASY HORSE

Here you'll get to draw a more standard four-legged horse. But wait, this one has wings, a horn and ... sundae toppings? Why not? Let your creativity run wild and try making a whole stable of friends for your ice cream horse.

### 1 Start With the Basic Shape

Draw a circle with crosshairs for the head. Draw a large circle for the chest and a smaller circle for the hindquarters. Connect them to form a pearlike shape. Then, pull a pair of sweeping, graceful lines from the top and bottom of the head to form the neck. The base of the neck forms a curved V shape on the chest (this is where the horse's shoulders begin).

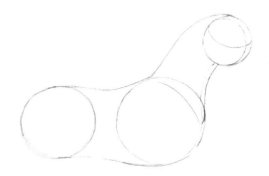

### 2 Block In the Legs and Face

Draw the muzzle and horn using the vertical guideline on the head as the starting point. Place the ears, evenly spaced, at the top of the head. Draw the eyes along the horizontal guideline, slightly more forward on the face than the ears. Start building the structure of the legs with a forelimb, followed by a small circle for the "knee" (actually the horse's wrist or ankle). From there, draw a shorter tube ending in a circle (this is the horse's fetlock). As you add the rest of the legs, draw guidelines to help align them.

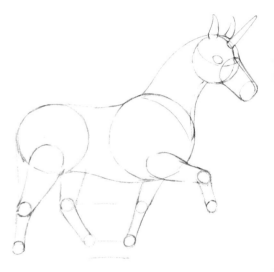

### 3 Block In the Hooves, Hair and Wings

Starting from the fetlocks, draw small hourglass shapes, and cap each off with a hoof. Note how the hooves slightly jut forward to help balance the horse's weight. Next, sketch the general shape of the mane and tail. The horse is in motion, so draw the hair flowing off the body as if wind were blowing through it. Block in the wing shape starting at the shoulder blades. Leave a gap between the wings to account for the width of the horse.

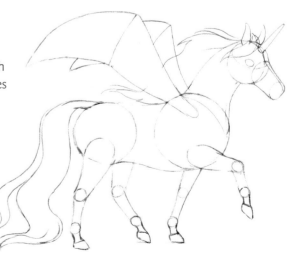

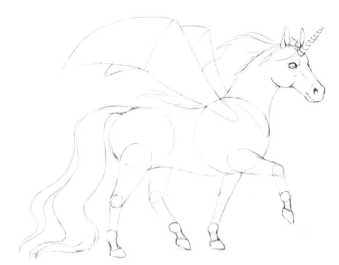 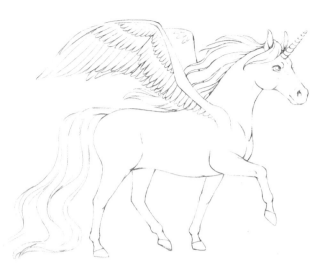

## 4 Refine the Face

Draw the large eyes (or eye from this angle) and frame it with dark, luxurious eyelashes. Then, draw the brows, nostrils, ears and mouth. Detail the horn with evenly spaced curved lines to form a spiral. Erase the face guidelines, but leave the bottom portion of the circle that forms the jawline.

## 5 Finish the Hair and Wings and Refine the Body

Section the wing into three rows of individual, overlapping feathers. (For more advice on drawing wings and feathers, see pages 72–74). Next, divide the tail shape into smaller sections of hair. Pull each section from top to bottom, using wavy, flowing lines. Repeat this process for the mane, pulling from the neck.

Refine lines and erase guidelines. The horse is a powerful animal; add some muscle definition to the leg and chest areas. Refer to photos of horses to help you bring out the horse's physique.

## TROTTING ALONG

Four-legged animals like the horse can be tricky to draw because they have two additional legs to worry about. Study photos and videos of horses in motion to properly position and weight the legs.

## 6 Add Finishing Touches and Color

Decorate your horse as desired. If you want to do an ice cream sundae theme, add sprinkles, candies and fruits in its tail and mane. Mint chocolate chip ice cream and some strawberry sauce complete the look. As you color your horse, think about the underlying muscle structure to bring out its majestic shape.

# Rodents

Straddling the line between loving and loathing, the human relationship with rodents is complex and divisive. We often invite rodents in the form of mice, rats, hamsters, gerbils and guinea pigs into our homes as pets, while battling to eradicate other rodents that plague our homes as unwelcome pests. Still, even as we denounce renegade rodents, we respect them as resilient, resourceful and downright cute. To that end, a number of anthropomorphic rodents have found prominence as beloved mascot characters in entertainment and other industries.

Capable of climbing, digging and even standing on their hind legs, rodents are a diverse and adaptable bunch. Their tails may differ in shape and function, and some bounce on their toes while others plant their whole foot firmly on the ground, but rodents share a mouselike design and a predominant feature: a pair of giant jutting incisors. From the squirrel's seed-cracking chomp to the beaver's tree-busting bite, buckteeth are a signature similarity across the species.

Far from the great galloping horses or fierce predatory cats featured earlier, most rodents are defenseless little chunky-cheeked fuzzballs, with a need to gnaw and a fatalistic curiosity. Because of their tiny bodies and unique proportions, rodents require special considerations when anthropomorphizing. So, grind your pencil's tip to a fine point because in this section we tunnel into the anthro rodent den and discover a cache of knowledge on making men of mice.

Hole Sweet Home
by Lindsay Cibos
10" × 11¼" (25cm × 29cm)

# Face

The chipmunk is a small rodent, about the size of a mouse, with features similar to those of a squirrel. Like most rodents, the chipmunk has a sloping convex face with a rounded snout, a small mouth that gently curves into the lower jaw, jutting incisors, large protruding eyes and thin-skinned ears low on the head. The chipmunk also has puffy cheeks with built-in pockets for storing food. You can use the cheeks as intended, or have your anthro squirrel carry other important objects in these living pockets (even if the idea is kind of disgusting). The chipmunk's most striking feature is its striped fur pattern. Be sure to capture these qualities in your drawing.

### 1 Sketch the Snout

Start with a circle and guidelines. From the crosshairs, pull out a medium-length straight line, and draw a flat triangular nose on the end. Pull a guideline down the center of the nose for later. Pull two lines from the tips of the nose back into the eyeline, spreading them apart as you go. Connect them across the middle of the face with an arched guideline.

### 2 Build the Brow

Beneath the nose, draw a small W-shaped mouth. On the chipmunk's left side, pull a backward-slanting line up from the base of the snout to the top of the brow, then arch the line in a sweeping curve back to its starting point. Because of the angle of the head, compress the brow when you repeat the process for the right side.

### 3 Draw the Cheeks and Ears

From behind the brow, pull a line back in a gentle curve to begin the chipmunk's chunky cheeks. Gradually contour the line around to the front of the face, ending at the mouth, to form the lower jaw. The chunky cheeks should have a full, boomerang-shaped appearance. Next, form the ears where the lower jaw meets the horizontal guideline by drawing a petal shape on both sides of the chipmunk's head.

### 4 Draw the Eyes and Details

Add the inner structure of the ears. From the center of the brow, draw the big round eyes. Open the mouth with a smile and draw the incisors under the upper lip. Erase the guidelines. Sketch in the chipmunk's patterning and final details, like eyebrows and nose slits. Add a couple of dashes across the bridge of the nose and brow to define the slope of the head and give the impression of facial fur.

### 5 Draw the Hair and Add Color

Rodents live life in the fast lane, so, for this guy, life's too short to bother styling his hair. Draft in a disheveled hairdo, and clean up stray lines. Then you're ready to add color. Chipmunks have a brown, gray and white color palette, reminiscent of fallen wood and forest debris. Color the face brown, using white and black for the patterning. Use flat black for the hair, and reddish brown for the iris.

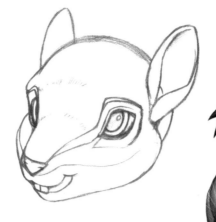

## DRAWING RODENT EYES

*Rodents might be small, but their eyes are so comparatively large that, for many species, they're hardly contained in the head. Functional, but uniformly beady, rodent eyes lack emotion. An anthro rodent with these eyes makes for a frighteningly alien-like appearance. Soften the look by letting a little white show.*

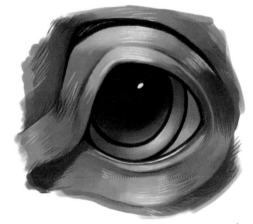

### 1 Sketch the Eye Shape

Lightly sketch a circle. Starting low on the side near the nose, draw a curved line slightly overlapping the eye to create the upper eyelid, ending on the opposite side of the eyeball. Draw the lower eyelid following the line for the bottom of the eye. This gives the appearance of a bulging eyeball barely contained.

### 2 Draw the Pupil and Iris

Between the eyelids, draw a large circle for the iris. Fill most of the circle with another circle for the pupil. On the pupil, draw a tiny circular highlight. Draw a skin fold above the upper eyelid and a thin rim beneath the lower lid.

### 3 Add Color

Clean up construction lines. Rodent eyes are generally black and beady, but to help humanize the character, you can enhance the eyes with some color. Dark purples and blues make a great substitute for black. Rim the pupil with a colorful iris.

# Full Body

Most of the rodents inhabiting the world today are minuscule creatures. To reflect the miniature body of a rodent, draw the head relatively large and give it body proportions similar to an average person but packed into a childlike frame.

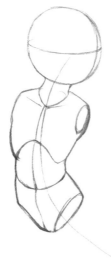

### 1 Sketch the Body Frame
Sketch the line of action with a pronounced curve midway down the line. Draw a large circle at the top of the line. Sketch the crosshairs on the side of the circle to indicate a head in profile. Next, sketch the neck and torso running along the upper arc of the line of action. Draw the body no wider than the circle representing the head to compress the character's overall size. Even though the body is small, draw the torso segments using normal proportions.

### 2 Sketch the Shape of the Limbs and Head
Sketch the basic head structure. Next, sketch the puffy tubes for the upper arms and thighs. Be careful when bulking out the hips. Keep the body frame relatively straight and angular; if he's too curvy, we'll question whether this is a chipmunk or a chipette. Draw the hands and feet: small wedges for the hands, slightly larger wedges for the feet. Following the line of action, sketch a twisting pipe of uniform thickness for the tail.

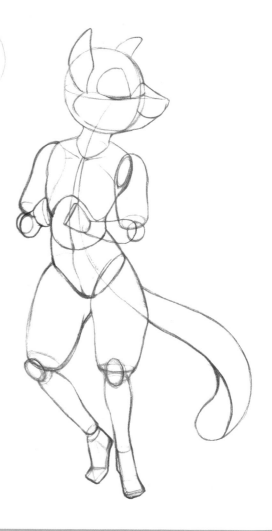

### 3 Establish the Body Contours

Complete the details on the face and indicate the hairline. Move through the image, erasing the construction lines and welding the body segments together. Keep the body details scant. Just establish the contours. When you're done, you'll be looking at a chipmunk minus any modesty. While the pantless approach works for Disney, this furry prefers fashion, so let's get him dressed.

### 4 Layer On the Fashion

Use a blue line pencil to lightly sketch the shape of the clothing over the body. Then, erase the body lines and draw in the layers of clothing over the initial sketch lines. Pay close attention to how the clothing hangs on the body and where it wrinkles. Draw a hat fitting snugly around the contour of his head (leave some holes for his ears to poke through). Give him a small music player and a pair of rodent-appropriate earbuds with a little slack in the headphone line. If you're creating your own fashion ensemble for this character, don't be afraid to use reference photos for ideas.

### 5 Add Color

Chipmunk colors range from yellow to brown, with tan or black stripes. This particular 'munk's fur is brown, gray and white. Enhance his neutral nature color palette with vividly colored clothing. You can tie the outfit together by repeating a color on multiple elements (for example, the hat, shoes and shirt are all green). Add some shading and highlights.

# Rodent Features

Rodents come equipped with tiny incisors for nut busting and wood chopping, articulated grabby little hands to manipulate and store, and a variety of tails used for balance and heat regulation.

## BASIC RODENT TAILS

### Draw a Line to Length
To draw most rodent tails, start with a simple line. The length of the line depends on the type of rodent tail you're making.

### Make a Mouse Tail
A mouse tail is the simplest rodent tail to draw. Starting with your line, continue the drawing back around itself, keeping the tip narrow and gradually widening the tail toward the base.

### Make a Gerbil Tail
Turn the line into a tube, then bristle the tail with a layer of fur that widens to a broad tuft at the tip.

## OTHER TAILS

Other rodents, such as squirrels, have tails specially suited to their ecological niche, and consequently call for a different approach to drawing them.

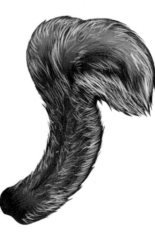

### Make a Hamster Tail
For a hamster's tail, cut the starter line way short. Turn the line into a small round-tipped stump that barely extends out from the body.

### 1 Define the Shape
Start by drawing a curving line indicating the center of the tail. Then draw a pair of tubes straddling the tail line. Gradually widen the tubes as you proceed toward the tip.

### 2 Bush Out the Tail
Erase the construction lines, leaving only the shape. Then, fluff out the tail with color. Start with the darkest color, and layer strokes of increasingly lighter color. The outermost layer of guard hairs is a different color than the inner coat. In the case of this gray squirrel tail, the guard hairs are white.

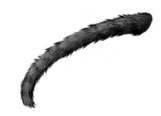

### Make a Vole Tail
Turn the line into a tube. Then bristle the tube's edges with a dense coat of short fur.

## RODENT HANDS AND FEET

Many rodent species have hands and feet that are similar to human hands, with distinct fingers and toes and not much fur. With only a few adjustments, it's simple to anthropomorphize them.

Most rodents have only four digits on their hands (plus a vestigial thumb). It's up to you whether your want to give your anthro rodent four digits like real rodents or five digits like a human.

 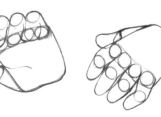 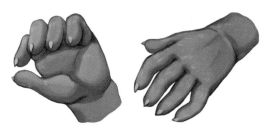

### 1 Sketch the Basic Hand Shape
Draw the basic boxy shape of the hand. Think of it as a 3-D object, but don't make it too boxy; keep the edges rounded. Add a wedge-shaped outcropping to the inner side (where the thumb attaches).

### 2 Draw the Fingers and Thumb
Sketch four fingers along the front of the hand shape. Use two segments instead of three to help keep the fingers short and rounded. This gives them the diminutive quality of a rodent hand. Then, extend out the wedge shape with a stubby thumb.

### 3 Add Details and Color
Erase the guidelines, leaving only the contour lines of the hand. Instead of human fingernails, draw little rodent claws on the ends of the fingers and thumb. Finally, add an appropriate flesh color, and detail with shading and a few flecks of hair.

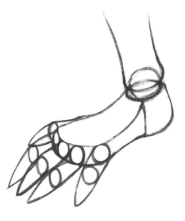 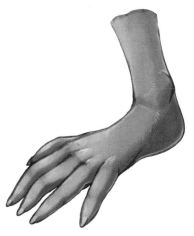

### 1 Sketch the Basic Foot Shape
Draw the basic shape of the foot like a human's foot. Rodents such as mice and rats also walk plantigrade (flat-footed), so the basic structure is similar.

### 2 Draw the Toes
Rodents have five digits on their feet. Draw the toe as two segments, splaying out along the end of the foot. The middle three toes are slightly longer than the toes on either end, with the inside toe being the shortest. End each toe in a rounded point.

### 3 Add Details and Color
Erase the construction lines. Color the feet the same fleshy color used for the hands. Then, add some shading and highlights. Finish the feet with some light-colored flecks for hair to give them a slightly fuzzy look.

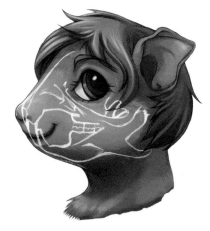

## RODENT TEETH

This hamster girl graciously models the rodent's most striking feature, a pair of continuously growing incisors in the upper and lower jaw. Note how the upper incisor overlaps the lower one. Farther back in the mouth are the molars, which aren't visible unless the rodent opens its mouth extremely wide. Rodents use the gap between the incisors and molars as short-term mobile storage.

# Action Poses

Unless they're sleeping, rodents seem to be in constant motion. Foraging for food, jogging on their exercise wheel, grooming or running away from predators—there are plenty of opportunities for creating action-packed poses for your rodent anthros.

## PIRATE RAT

Rodents, always on the lookout for hoarding opportunities, regularly risk their lives to line their burrows with riches. Clever and industrious, rats strive to find the quickest path to rewards, even if it means stealing from others. Ships laden with cargo offer ripe targets for rats willing to brave the seas in search of plunder. Arrgh!

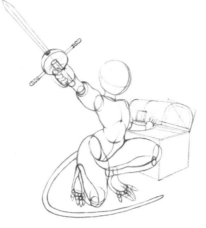 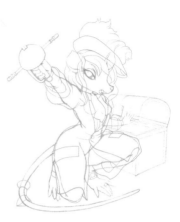

### 1 Sketch the Basic Figure

Draw a circle with crosshairs for the head. Then, sketch the shape of the torso with a strong arching back. Rats have compact bodies with chunky upper arms and thighs, so oversize these areas on her small frame. Increase the size of her right hand and the sword as it comes toward the viewer and decrease the size of her left arm. Use a ruler to draw rigidly structured objects like the treasure chest and the sword. Add a tail and rat feet.

### 2 Dress Up the Pirate Rat

Use the head crosshairs to place the half-closed eye, ear, muzzle and hair. Then, erase the construction lines for a clean body silhouette. Using a blue pencil, lightly sketch pirate attire, including a feathery hat, a long overcoat and more. Shiver me timbers!

### 3 Add the Finishing Touches and Color

Place folds in the clothing where the body bends, such as around her midsection and knees. Add some spiraling ringlets to the base of her hair for a classical period look. Finally, color her outfit, hair and sword with warm colors such as yellow and red to create a sense of excitement. Then, work some cool colors like purple and blue into the shadows to play off the warm colors.

## FLYING SQUIRREL NINJA

*Flying squirrels zip from tree to tree like a ninja in the night. One of the greatest difficulties with anthropomorphizing flying squirrels is finding clothing that fits them. With large skin flaps attached to their front and back legs for gliding, their bodies are essentially shaped like flat squares when fully outstretched. Loose-fitting clothing works best with this body type; coupled with the flying squirrel's nocturnal nature, ninja garb is a good fit for them. Besides, who doesn't love ninjas?*

### 1 Sketch the Basic Pose

Draw a bulky figure with outstretched arms and legs. Sketch the crosshairs on the face looking straight ahead (so he can see where he's going!). Pencil in the furry membrane attached to his wrists and ankles; this is what allows him to glide. Draw the tail curving from the base of the spine. Keep the tail relatively flat; flying squirrels' tails aren't large and bristly like their diurnal (active during the day) squirrel cousins. Don't forget to equip him with a shuriken (the ninja's throwing weapon).

### 2 Add Ninja Clothing and Color

Sketch the general shape of the ninja outfit loosely around the contour of the squirrel's body, including his skin flaps. He should look a bit like a flying sack. Then, detail the outfit with wrinkles, folds, a belt around the waist and an over-the-shoulder short sword. Finally, add some color. Flying squirrels are nocturnal, and ninjas rely on stealth attacks, so paint his outfit the darkened shade of night. His enemies will never know what hit them.

# Rodent Variations

From the diminutive mouse to the prickly porcupine, over 40 percent of mammal species belong to the order of rodents. While they all have a pair of big, sharp incisors in common, there is plenty of variation between different species. That means plenty of inspiration to pull from when creating your rodent anthro characters.

## MOUSE

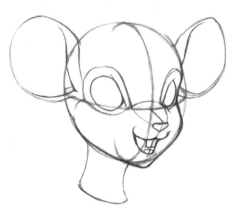

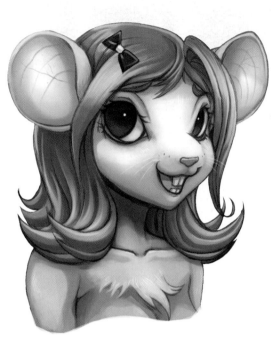

### 1 Sketch the Basic Shape
Working from the basic circle with crosshairs, draw soft, rounded features, including large, circular ears, a gently curving snout and large, round eyes. Draw a pair of sharp incisors to give her a cute toothy smile.

### 2 Add Details and Color
Clean up the construction lines and finish detailing the character. Give her a hairstyle that complements her cute appearance. Mice ears are semi-transparent, so paint in a few blood vessels and add a strong highlight shining through the middle of the ear. Mouse fur comes in many colors, but this girl is an albino (white fur and red eyes).

## PORCUPINE

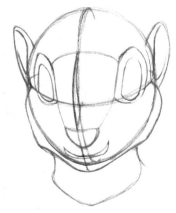

### 1 Sketch the Basic Shape
Porcupine faces are boxy. Give the cheeks and chin strong, straight lines with only slight curves. Draw the snout wide with a large nose. Draw the eyes and brow from the ends of the snout. Keep the small ears seated low on the head and close behind the eyes.

### 2 Add Details and Color
The thick keratinized hair that forms into stabbing quills is the porcupine's most prominent feature. An interesting way to anthropomorphize the quills is to draw them as spiky hair. Then, draw in his facial features. Porcupines are slow and steady animals, so a relaxed expression is suitable. Finish off the portrait with some more facial hair, then add color. Porcupines come in shades of brown, black and gray.

## Fashion Bunny

Technically, rabbits aren't rodents; rather, they belong to the order of lagomorph. But the two groups share some superficial similarities, such as the incisors and continuously growing teeth. When drawing rabbit anthro characters, emphasize their elongated ears, short fluffy tails, strong legs and big feet. Don't forget those incisors—rabbits love to chew as much as rodents do!

## Shy School Boy

Guinea pigs have round, stocky bodies with proportionately large heads. When possible, give your characters something to do with their hands, such as holding an object. Guinea pigs love vegetables, so a stick of celery makes a great accessory.

# Morphology

There is no set rule to how much you must anthropomorphize your characters. You can go all out with fur, ears, tails, claws and more, or pick and choose just a few of the most prominent features. It all depends on your goals for the image.

## MORNING MOUSE

Mice are meticulous groomers, and this mouse girl is no different. Not even out of bed yet, and she's already grabbing for the hairbrush. In this demo, the rodent features are relatively limited: incisors, mouse ears, nose and tail, while the rest of the character remains human.

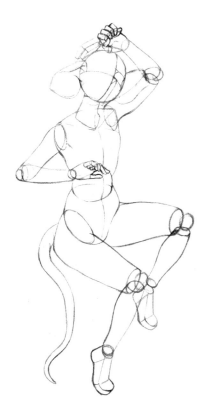

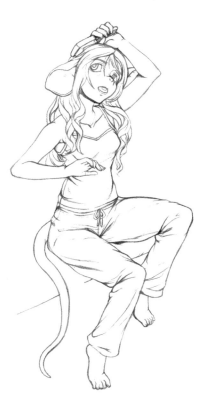

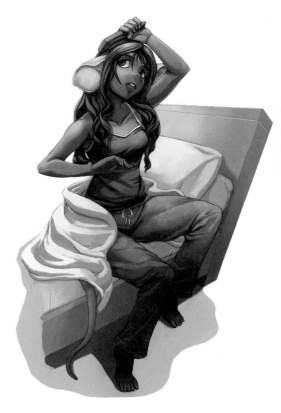

### 1 Sketch the Body Structure

Start with a circle for the head. Draw the crosshairs to indicate that the character is angling her head upward. Then, work through the rest of the body, positioning the legs, arms and torso in a seated position. Add basic mouse features, such as a tail, a curvy snout and large, round ears.

### 2 Fill In the Details

Draw in the mouse girl's pajamas following the established body lines, including details such as folds, drawstrings and trimming. Then, work out the shape and features of the face (eyes, brow, teeth, lips and snout). Draw the long wavy hair around her ears and shoulders. Add toes and fingers. Tighten stray lines and erase any remaining guidelines.

### 3 Draw the Background and Add Color

Draw in the bed, pillows, sheets and a towel to help give your drawing a sense of setting. Then, add some color. Fill in the basic colors, then work up the shadows and highlights. Put the light source behind the character to suggest the sun shining through a bedside window. Add deep shadows under the bed to give the picture more pop.

## ADVENTURING MOUSE MAGE

*Let's try drawing a mouse with human-inspired characteristics. This little guy has the anatomy of a mouse but stands on his hind legs, wears a thoughtful, human expression and equips himself with a staff and cloak. Let the adventure begin!*

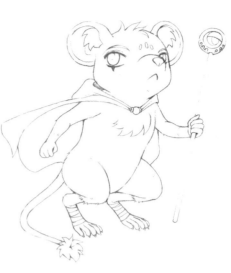

### 1 Build Up the Basic Shape
Draw a sweeping line of action to establish the pose. Sketch a circle with crosshairs for the head and another directly underneath it for the chest. You don't need to draw a neck to connect the two shapes; mice do have neck bones, but, with their compact frames, the neck isn't really visible from the exterior. Sketch the lower torso, following the curve of the line of action.

### 2 Develop the Figure
Draw the arms and hands. Use a ruler to achieve long straight lines for the pole of the staff. Draw the legs and feet. This guy is standing on his toes to get a better look at his surroundings, but remember that mice are plantigrades; they walk on the soles of their feet. Pull a tail from the base of his spine and give it a slight curve for a balanced look. Sketch the basic shape of the eyes, ears and snout.

### 3 Fill In the Details
Draw the facial details. Give him human expressiveness through the use of details like eyebrows, a small frown and a sidelong glance. Add ovals on the forehead and a downward streak on the eyelid to give him an air of mystery. Draw tufts of hair on the head, ears, chest and tail to fluff him up. Fill out the fingers and toes: four digits on each hand, five digits on each foot, all capped with little claws. Add clothing details, like a billowing cloak and bandages on tired, adventuring feet.

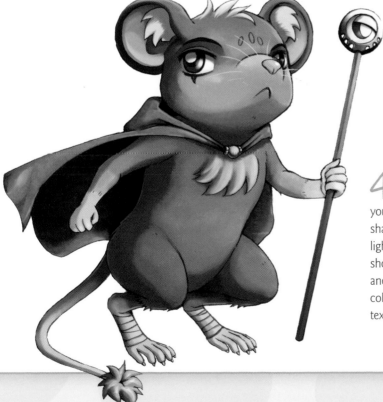

### 4 Add Color
Clean up rough lines and erase remaining guidelines and you're ready for color. Start with a base color, and build up the shadow and highlight colors from there. Use small flecks of a lighter color to give the appearance of short fur. Indicate skin showing through fur by coloring the nose, the inner ear, the tail and the ends of the arms and legs a pinkish flesh color. Use sharp color contrast to bring bright metallic shine to the staff. Work texture into the cloak for added visual interest.

# CHAPTER 5

# Birds

There's no denying our love of birds: from their tranquil songs to their feathered beauty, we appreciate them both in our homes as chirpy pets and in their natural habitats.

Humankind has long been fascinated and envious of the bird's ability to fly freely through the skies. But even the ones that can't fly, like penguins and ostriches, charm us with their cute looks and quirky mannerisms.

In terms of anthropomorphism, birds present new drawing challenges. In some ways, their bipedalism (moving on two legs) makes them easier to anthropomorphize than quadrupeds like equines. On the other hand, characteristics like wings, feathers, beaks and talons call for new techniques. Eager to dig in with your talons? Then leap out of the nest, and get ready to take your anthro avian art soaring to new heights.

*Reluctant Crossing*
by Lindsay Cibos
9¾" × 10¾" (25cm × 27cm)

# Face

*The facial features of our feathered friends differ substantially from those of mammals, particularly beaks and feathers. Beaks call for close attention to structure. The bony beak, lacking the pliancy of skin, needs to remain rigid while* *allowing the character to express emotion. The process for drawing the soft plumage around the face is similar to drawing fur.*

### 1 Sketch the Upper Beak
Sketch a basic circle and guidelines. From the crosshairs, pull out a line indicating the length of the beak. At the end of the line, draw a slanted diamond shape to create the down-pointed beak tip. Above the crosshairs, sketch the general shape of the upper beak. Pull the beak down to the horizontal guideline in a soft V shape. Spread the beak wide across the face, then connect the lines on the face to the points at the beak tip.

### 2 Sketch the Lower Beak
Draw a pair of guidelines arching down from the front and back center of the upper beak to place the partially opened lower beak. Create a floor to the lower beak by drawing a broad U shape that connects the corners of the beak with the arching guideline in the rear. Then connect this shape with the guideline at the front of the beak. Draw the beak's biting edge by following the contour and grooves of the upper beak.

### 3 Sketch the Facial Features
Starting where the beak touches the horizontal guideline, draw a curved line back around the face to form the brow. Pull a guideline across the forehead and draw a matching brow on the other side of the face. Centered beneath the brows, draw a pair of large, oval slits for the eyes. From the back of the face, beneath the brow, sketch a sharply curved jawline extending off the circle and connecting into the bottom of the lower beak. Next, draw a wide tube from the base of the head to make the neck. Add an open triangle on the beak for a nostril.

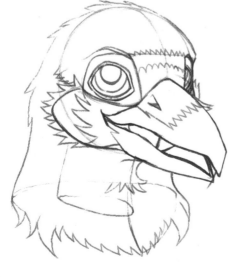

### 4 Add Plumage
Clean up the beak to reduce the number of guidelines. Then, fluff up your bird with lots of feathers. Don't draw individual feathers; instead, use strategically placed jagged lines to create the illusion of feathers. Partially cover the raven's upper beak with a sharp line of feathers over the nostrils and add a thick layer of plumage around the neck, bulking it up considerably. Then, sketch the eyes and eyebrows.

### 5 Add Details to the Face

Clean up any remaining guidelines and erase the lines on the beak where feathers overlap. Detail and refine the edges on the plumage. Draw some choppy hair onto the bird's head. Use angular strokes to give the hair a style that naturally blends in with the feathers. Add details to the eyes and brow.

### 6 Add Color

Use colors like dark purple, red and blue to capture the iridescent look of the raven's oily, black plumage. Use a lighter, more saturated color like purple on her hair to make it stand out from the facial feathers. Scatter brushstrokes of white and light blue to highlight feathers and imply wear marks on the beak. Raven eyes are generally brown, but feel free to use whatever color suits your character best (in this case, brownish red).

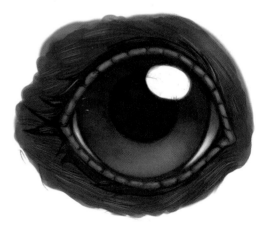

## DRAWING BIRD EYES

*Greatly reliant on their sense of sight, birds have large eyes. The often very colorful irises fill most of the visible surface of the eyeball. Because birds substitute feathers for hair, you have the option of drawing feathery or fuzzy lashes around the eyes.*

### 1 Create the Basic Eye Shape

Start by lightly sketching a circle as a template for the eyeball. Then, draw a pair of arched lines sweeping across the circle, meeting at points directly across the eyeball from one another.

### 2 Draw the Iris and Pupil

Sketch the iris as a large circle filling most of the visible eyeball. Within the iris, sketch a much smaller circle for the pupil. Create a highlight by sketching an ellipse over both the pupil and iris. If you find the bird's intensely focused eye too startling, tone it down by increasing the size of the pupil or by lowering the upper eyelid over the pupil.

### 3 Complete the Eye and Add Color

Erase the construction lines and draw a thick rim encircling the eyelid. Break this rim into small bumpy segments. Add final details, like feathery eyelashes extending out of the silver-gray eye rim. For a close-up, encircle the eye with sketchy lines indicating backswept bristling feathers. The common raven's iris is black, but if that's too plain, substitute white, yellow or blood red.

# Full Body

This raven demonstrates a bird's most striking feature: its wings. Wing size and shape varies, but in general wings get big, so be sure to give yourself plenty of room.

Flight birds, spending much of their lives in the air, require a strong body frame bristling with lightweight feathers. Draw your bird character with large wings, a puffed up chest and muscular thighs.

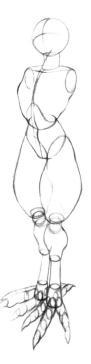

### 1 Sketch the Body and Legs

Sketch a curving line of action, then use it as a guide to stack the torso elements. Sketch the raven's chest wide and deep, implying powerful muscles and cavernous lungs. Create a powerful set of avian legs by sketching slender tubes that balloon out at the thighs, then narrow again at the knees. Draw an abbreviated lower leg that extends about half the normal length. Like the thighs, give the legs extra girth around the center. Draw a slender shaft for the ankle, ending in a wide cylinder for the foot. Draw three talon-tipped toes extending out from the front and one from the back of each foot.

### 2 Draw the Face and Wing Arms

Draw the raven's facial details. Don't go overboard on the plumage yet. Move on to creating the wings by first starting with a new line of action to help define their sweep. Drawing wings can be challenging, but it becomes easier once you understand some basics of wing anatomy. Think of the wings as a pair of human arms with feathers extending from them (see other wing configurations on page 74). Using the line of action to guide their position, draw the arms and hands.

### 3 Feather the Wings

Bird wings have three segments, corresponding with the hand, forearm and arm. Each wing segment has three layers of overlapping feathers with the smallest layer towards the top of the wing. Build the wings by first sketching the long bundles of flight feathers fanning out from each of the three segments. Second, sketch a layer of feathers running along the top of the wings, overlapping the flight feathers. Third, add the final layer of feathers by loosely tracing the length of the arm from the thumb to the underarm. Draw the raven's tail feathers splaying down from the lower back.

### 4 Clean Up and Add Clothing

Clean up construction lines on the body. Start laying down the construction lines for some bird-appropriate outerwear. Wings and tail feathers pose all sorts of problems for conventional clothing. A broad-sleeved, kimono-style top gives the character plenty of room to move, and a pair of capri pants shows off her bird legs. Be sure to leave space for the tail feathers to emerge through the clothes. Sketch a cute beanie cap on her head; it'll keep her warm in flight.

### 5 Finish the Feathers and Add Color

Split the segment of the wing attached to the hand into ten individual flight feathers. Draw a bump along the inner length of each feather as it proceeds towards the arm. As you move down the wing, draw each new feather underneath the previous one. Then, draw nine more feathers on her arm segments. Next, sketch the smaller second and third layers of feathers, each overlapping the previous layer. Finish with a splash of color.

# Bird Features

The physical traits of birds include a beak, a lack of teeth, feathers, wings and scaly feet. Follow along to create a specific bird anthro, or mix and match features to create a unique bird.

## WINGS

In lieu of arms and hands, birds possess wings, which work great for flight, but aren't so suitable for gesturing or manipulating objects. Here are some ways you can combine human anatomy and bird anatomy to address the issue of wings as hands in your anthro art.

### Wings as Arms

This character remains structurally close to his mallard duck roots, with fully formed wings. He can, however, point to and hold objects using his primary flight feathers as fingers.

### Hand and Wing Hybrid

Wings extend out from this duck's human arms, giving her human hands while retaining the appearance of wings.

### Wings and Arms Separate

This hawk lady enjoys the best of both worlds: a pair of bird wings sprouting from her back and the convenience of human arms, enabling her to fly and hold objects at the same time.

## FEATHERS

Several different types of feathers make up a bird's colorful plumage. The following drawings show a couple types you'll encounter.

### Contour and Flight Feathers

Stiff outer feathers cover the surface of the bird. They consist of a central shaft with vanes made up of small barbs that come together like a zipper to form the smooth shape of the feather.

### Down Feathers

These are soft, fluffy feathers beneath the contour feathers that insulate the bird. Unlike the contour feathers, the barbs on down feathers don't "zip" together into a cohesive shape.

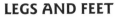

## LEGS AND FEET

Drumstick, anyone? Birds walk digitigrade, the ankle elevated high above the rest of the foot. So the "bird leg" that starts midway down the length of the lower leg is actually the bird's long ankle shaft.

Some birds, particularly wading birds, have twiggy legs with no plumage all the way up the thighs, while others have long feathers cloaking their legs nearly down to the talons. But generally, the feathers stop at the ankle, exposing tough, scaly skin.

Bird feet come in a number of shapes and toe configurations that vary between families, each specialized for different tasks (perching, walking, hunting, swimming and so on).

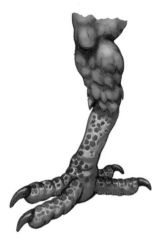

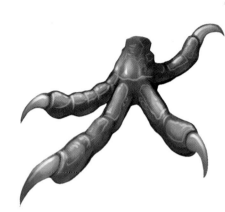

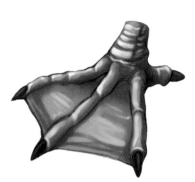

### Parrot Split Foot

Parrots sport a split foot arrangement with two toes in the front and two toes in the rear, excellent for climbing and grasping. Cover the leg with plumage and call the foot done.

### Perching Bird Foot

Perching birds have thin, spindly toes, three in the front, one in the back, well suited for, what else, perching.

### Duck Foot

Ducks have webbing between their toes that enhances their swimming ability.

## BEAKS

Beaks come in numerous forms adapted to how the bird feeds. In anthro art, there's less concern over the bird's dinner menu and more interest in the area of humanlike expressions. Though their rigidly built beaks can make it tricky to depict emotion, it's still possible. Using just the beak, here are some examples:

Happy Vulture

Flirtatious Parrot

Surprised Ibis

Angry Finch

Uncomfortable Duck

# Action Poses

Birds are at their most majestic when they're flying through the air: soaring, gliding and diving. The gift of flight enables birds to be in places and achieve things impossible for terrestrial animals. But don't discount the swimming capabilities of waterfowl or the high-speed running and powerful kicking of ground birds like ostriches. The opportunities for depicting birds in action are vast.

## MENACING FALCON

It's easy to cast a falcon as a villain. He's a lone hunter who keeps to himself and victimizes smaller birds. The peregrine falcon stalks targets from great heights, waiting for the right moment to jump its victims. Diving at speeds over 200 mph (320 km/h), the falcon streaks down, landing a lethal knockout kick without warning.

### 1 Draw the Figure

Sketch the body from a low angle. A ground-level view brings attention to his tearing talons and adds drama to the pose. To sell the action of a falcon looking down at potential victims, draw the corner of the building. This piece of setting clues in viewers that the falcon is up high; without it, he could just as likely be squatting at ground level. Draw the wings half-opened and a hand gripping the side of the stone to show he's ready to launch into the air to strike.

### 2 Add Details and Color

Dress your bad-boy falcon with appropriate street wear. On the parts of the body that remain visible, like his wings and tail, pencil in the feathers. Tighten any sketchy lines and erase guidelines to complete the drawing. Color him with dark shadows and cool blues to give him a cold and calculating look.

## FLUTTERING HUMMINGBIRD

*Hummingbirds are small birds that hover in the air, allowing them to drink nectar from flowers through their long, needlelike beaks. They hover by rapidly beating their wings, often so fast that the wings look like a blur.*

### IT'S ALL A BLUR!

For characters in motion, you might want to work some motion blur into your picture. You can do this with the line work, the colors, or both, by making the form of the object you wish to blur less sharply defined. In the hummingbird's case, streaking some additional color past the tips of the feathers helps give the illusion of fast-moving, flapping wings.

### 1 Draw the Basic Form

Sketch a circle with crosshairs for the head. Draw circles for the eyes and a long, straight tube for the beak. Capture the small size of the bird by keeping the body frame compact. Hummingbirds tuck their legs into their feathers during flight, but the pose doesn't look so elegant on human anatomy. Instead, pull the legs up behind the character as if she were kneeling.

### 2 Draw the Wings, Feet and Facial Details

Pull flowing pencil strokes from the hairline to sketch long, wavy hair. Draw the wings sprouting from her shoulder joints, and split the wings into segments. Draw the tail as two segments. Place four toes on the end of each foot: three in the front, one in the back. Rough in the facial details, including gentle downcast eyes, brow and cheek definition and feathers covering the base of her beak.

### 3 Refine Lines and Add Color

Fill in the wing segments, starting with the primaries at the end and working inward so they overlap correctly. Next, refine the lines and add detail to her hair while retaining the flow and shape of the underlying sketch. For clothing, follow the underlying body structure and build upon it for a perfect fit. Draw some small, half circles on areas not covered by clothing to give her body a feathery texture. Draw curving talons on each of her toes, and set the scene with a nectar-bearing flower. Finally, color her with hues of green and black (although she's a ruby-throated hummingbird, the females lack the red coloration of their namesake).

# Bird Variations

From the mighty ostrich, standing at up to 9 feet (3m) tall, to the minuscule bee hummingbird, literally about the size of a bee, birds can vary greatly, and not just in terms of size. Bird feathers come in a great variety of colors and patterns. Male birds are typically more vividly colored than females, though it depends on the species. As always, study reference photos for exact details.

## STARING AT SYMMETRY

When you're drawing a character looking straight ahead, it's especially important to keep an eye on the symmetry. As you block in the structure, periodically hold it up to a mirror to check for lopsidedness. Use rulers and guidelines to help line up the character's physical features.

**WOOD DUCK**

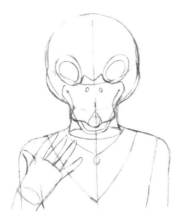

### 1 Sketch the Basic Structure

Start with a circle and forward-facing crosshairs for her head, and fill in the eyes. Sketch the hook-tipped bill wide across the face, and place two circular nostrils. Draw the shoulders.

### 2 Add the Details and Color

Finish drawing the hair, eyes, outfit, necklace and flower accessory. Then, refine the lines and erase any unnecessary marks. Female wood ducks are a modest black, gray and white, with a hint of blue. Concentrate the white around the eyes and neck. Work some black coloration into her hair and blue-grays into her general plumage. Finish with brighter tones on the clothing like blues and yellows to bring some color into the picture.

### Waddling Along

Penguins are stout birds with a wide frame and an upright posture. Unlike most birds, penguins are plantigrade. On their feet, the toe usually set in the rear on other birds is housed on the front of the foot, like a stubby dewclaw.

### Penguin Diver

Although penguins have great underwater vision and are insulated by a layer of air beneath thick feathers that keep cold water away from their skin, this one likes to wear goggles and a diving suit. Perhaps as a fashion statement?

## TOCO TOUCAN

### 1 Sketch the Basic Structure

Start with a circle and crosshairs for the head. Fill most of the front portion of the face with the toucan's extraordinarily large, but lightweight beak. Then, draw the brow and eye area into the side of the beak. Draw the neck as wide as the head, and connect it to a sturdy body frame. Indicate extra plumage puffing out of the throat by sketching a ruff extending down from the cheeks and across the middle of the chest.

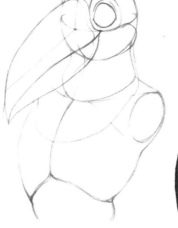

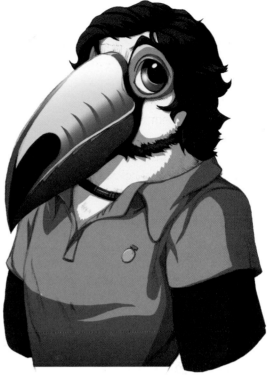

### 2 Add Details and Color

Draw the details of the face, including the toucan's bumpy brow and gentle eyes. Add some hair to the head and along the face. Next, draw the details of the beak: a serrated edge along the inside, a black spot near the tip and a rim along the face. Dress your toucan with a shirt and accessories, and he's ready for color. The plumage of the Toco toucan species is black and white with a hint of red under the tail; his most colorful feature is his beak: a mixture of orange, yellow and red. On real toucans, the eyes are brownish with blue surrounding skin, but there's no harm in taking some creative liberties.

### Princely Peafowl

This Indian peafowl flaunts a stunning display of iridescent blue-green tail feathers, a feature for which the peafowl species is famous. Only the males (peacocks) possess the long, flashy tail. Because he's an anthro, this dashing individual also seeks to impress with his equally dashing aristocratic garments.

# Morphology

Do you want to create a character that's mostly human with just some feathers as an accent, maybe some wings and a beak, or perhaps an all-out bird character with human intelligence? Here are some more ideas for anthropomorphizing your characters.

## DANCER TAKES FLIGHT

This joyful dancer is 100-percent human, but her feather-embellished costume, with a cape draping from her arms like a pair of wings, immediately brings to mind the image of a bird.

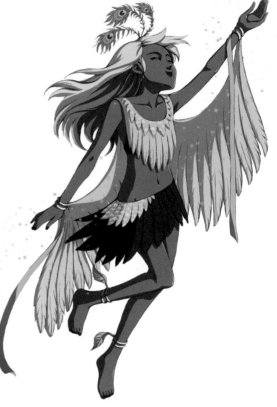

### 1 Sketch the Torso

Start with a circle and crosshairs pointing upwards. Draw the cheek and jawline out from the horizontal guideline; take care to draw the underside of the face when you reach the chin. Pull the neck down to the shoulders, then draw the torso, turned the same direction as the head. Draw the center line down the torso with a gentle curve as it travels the peaks and valleys of the body frame. Draw circles on the shoulder and hip regions to indicate arm and leg placement.

### 2 Draw the Limbs and Costume

Extend the arms from the shoulders, one reaching towards the sky, the other resting at her side. Draw the legs with a playful step, her right foot kicking up, her left foot barely brushing the ground, for a lighthearted and weightless pose that captures the grace of a bird. From her wrists, sketch the general shape of a cape draping around her back and over her chest. The goal of the cape is to capture the look of feathery wings, but keep the design simple for now so you can focus on the pulling and movement of the fabric. Sketch the skirt with a basic jagged outline.

### 3 Add Details and Color

Divide the skirt and cape into segments of feathers. Give the feathers a slight overlap and a hint of fringe along the edges. Turn the generic straps on her wrists into bracelets; add dimensionality by extending the shape past the skin. Tie the costume together with additional details like feather anklets, earrings, flowing of fabric and decorative feathers in the hair. For her colors, consider taking inspiration from a bird's colorful plumage. The peacock's color palette of blue and green brings this dancer to life.

## FANTASY OWL

*With their large forward-facing eyes and piercing gaze, owls are often used as a symbol of wisdom. Although some folklore depicts owls as an ill omen, other fairy tales elevate them as intelligent beings and wise messengers, sometimes able to speak human languages.*

*The physical features of this fantasy owl are inspired by several different species: the body and face from the screech owl and the tawny owl, and a pair of ear-shaped tufts from the great horned owl. His coloration is, of course, pure imagination.*

### 1 Sketch the Basic Shape

Draw a circle with crosshairs for the head. Beneath that, draw a much larger circle for the owl's chest. Draw a small circle halfway beneath the larger circle to make the lower torso. The owl's body should have a forward lean to it when you're finished drawing the foundation.

### 2 Finish Drawing the Figure

Draw two circles for the eyes, evenly spaced along the horizontal guideline. From the crosshairs, draw a closed beak with a subtle smile. Sketch a pair of wings. To draw his open right wing, sketch the general shape, then draw a vertical line down the middle where it would fold, and then two horizontal lines to create feather layers. Pulling from both sides of the lower torso, draw the tail feathers relatively flat. Sketch the legs and feet by breaking the shape into sections where bends occur.

### 3 Add Details to the Figure

Fill in the individual feathers on the wing and tail; take your time to overlap and define the shape of each feather. Draw a ruff of zigzag-shaped feathers around the chest. Add a few layers of loosely hanging feathers around the knees and ankles, fitting him like a pair of pants. Draw sharp talons on the tips of his toes. Accentuate the head and tail with a stylish plume. Finally, define the head and add facial details including eyes, brows, ear-shaped tufts and patterns.

### 4 Refine Lines and Add Color

Erase the construction lines, clean up any stray lines and refine the details. While valid choices for a standard owl, colors like brown, white, and gray lack any magical qualities. Be brave with your color choice. Try pinks and purples or blues and greens, unusual colors that grab attention and indicate that this owl is different from the flock.

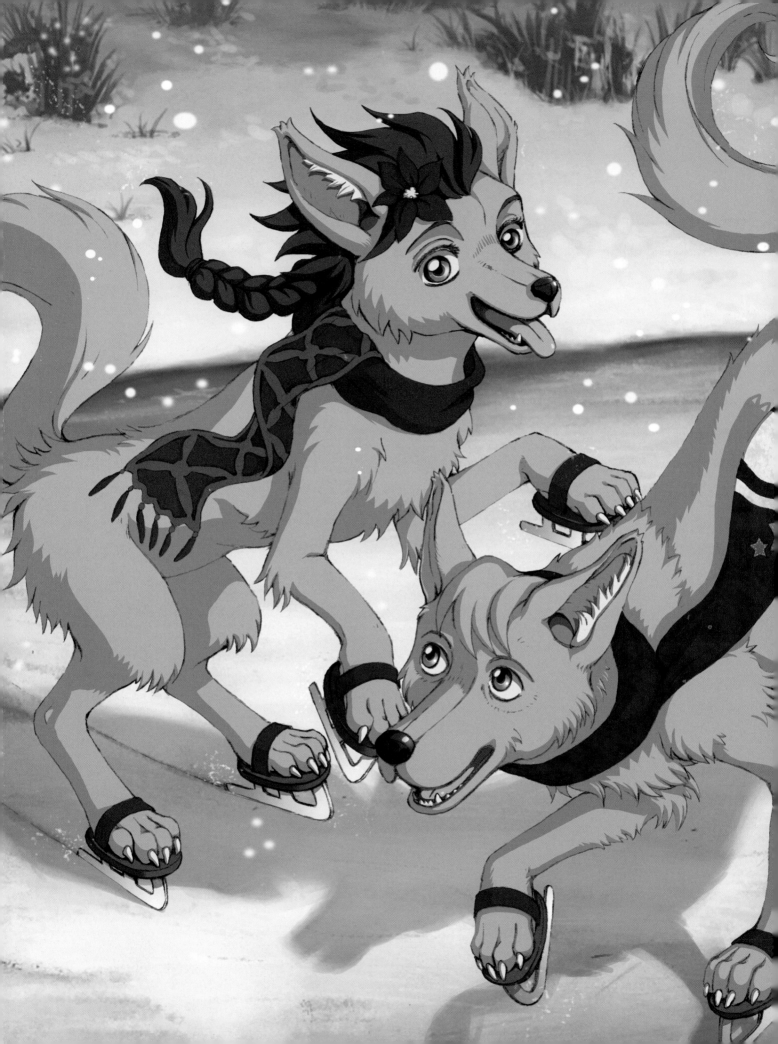

# CHAPTER 6

# Furry Extras

If you consider the animal-specific chapters leading up to this point as the main-course meal, then this chapter is all about the condiments, the tasty extras that add flavor to your furry art:

- Learn how to spice up your anthros with clothing and accessories that suit their species and body types.

- Or, if plain is your flavor of choice, learn how not to dress them (for the furs who prefer to remain unclothed).

- Find out when and where to pile on the fur for additional garnish.

- Read tips on peppering in extra wings and tails for a taste of fantasy.

So, grab a fork and plate—pencil and paper—and turn the page to dig in at the buffet!

*Paws on Ice*
by Lindsay Cibos
7¾" × 9" (20cm × 23cm)

# Furry Customization

There's more to an anthro character's appearance than just species and build. You can customize your characters by supplying additional fur, tails or even wings.

## PILING ON THE FUR

Anthropomorphic characters aren't called furries for nothing! Once you've mastered the basics of depicting soft animal fur, try double and triple layering on the hair for a fluffier look. Some animal species naturally call for extra heaps of fluff (snow leopards, yaks and sheepdogs to name a few), but fur can also be used to accentuate otherwise short-haired anthros.

### Fur on the Arms
Tufts of fur hang from the shoulder and elbow. By varying sections with short hair and long hair, you can create an extra-furry character that retains a sleek figure.

### Extra Fluffy
Puffy tufts of additional fur cover this Maine coon-inspired cat girl: around the neck, shoulders, hips and elbows, in the ears and along the body. Separate the sections of fur using jagged lines and strong shadows to help build the illusion of thickness.

### Fur on the Legs
Hips, thighs and knees are excellent locations for more fur. A super-bushy tail completes the long-haired look.

## Extra Wings

For a magical touch, try drawing wings on anthros not normally bestowed with the gift of flight. This girl would be an ordinary cat if it weren't for the mysterious bat wings sprouting from her back. The unexpected element compels viewers to take a second look. For inspiration, study real flying creatures: the gossamer wings of insects, the downy wings of birds and the fibrous wings of bats, each with unique textures, shapes and designs. When drawing clothing on winged characters, use open-back outfits that allow the wings space to stretch and move.

## Where Do They Come From?

Draw multiple tails coming from the base of the spine, or as close to that general area as possible. Just as other parts of the body are symmetrical, arrange tails in a balanced fashion with the top tails overlapping the lower tails. To avoid confusion and mistakes (more tails means more body parts to keep track of), sketch a rough draft to plan for how much space the extra tails will require.

## Extra Tails

Tails swish and sway, providing visual interest and lively movement to an illustration. They droop and puff, suggesting a character's emotional state. They grasp and hang, acting like a fifth appendage. With so many benefits, it's not surprising that the phenomenon of extra tails is commonplace in anthro art. After all, what's better than one tail? How about two (or three or more)?

## A NINE-TAILED LEGEND

In eastern folklore, it is said that *kitsune* (Japanese for fox) can grow as many as nine tails. They gain additional tails and supernatural abilities as they age.

# Clothing Considerations

Clothes enable a character to express her individuality at a glance; you can learn a lot about someone's interests and personality by looking at the garments she chooses to wear.

## ACCESSORIZING WITH ANIMAL APPAREL

Harnesses, collars, leads and tags are restraints designed to conform comfortably to a creature's build. Originally created with utility in mind, these iconic animal accessories may seem an odd fit for half-human anthros, but divorced from their original function, they can become another fun element of fashion.

### Bridle

Made from a series of interlocking straps, a bridle is a piece of equine headgear designed to allow a rider control over a horse's movement. Because of its prominent position on the horse's head, the bridle can also act as a decorative center-piece, like a crown or tiara.

### Dressing Up That Tail

As a rule, if an accessory works on the arms or legs, you can place it on the tail. On the pretty side, consider adorning tails with ribbons, ties, jewelry and frilly fabric. Tech-minded anthros might have strappable gadgets like watches and music players. Fighting anthros can weaponize the tail with weights and spikes, or protect the tail by encasing it in armor. The tail functions as a fifth limb, so avoid adding accessories that encumber your anthro.

### Fashion Mishap!

Not every animal is equal in the world of fashion. As with humans, certain outfits just don't work on certain body types. Be careful about tight fitting clothes on excessively furry and feathery creatures.

### Collar Necktie

Collars make an obvious fashion accessory for cats and dogs. For the business-minded furry, put a twist on the classic look by looping the collar over itself to create a tie.

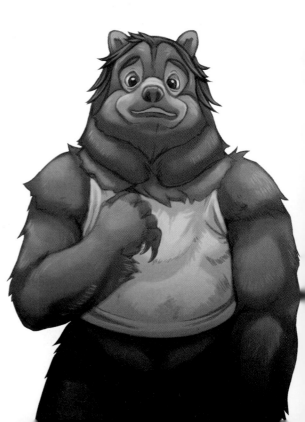

# Make Room for That Tail!

Whereas human clothes are designed with four limbs in mind, anthro attire requires some design tweaks to accommodate the extra appendage.

### From the Front

Even if you can't see it, it's a good idea to think about how the tail is coming through the clothes, so you can draw the sweep of the tail correctly. To figure out where the tail starts, find the center point midway down the character's pelvis, and follow it to the back end.

### Low-Rise Pants

Low-rise pants allow most tails ample freedom without any anthro-specific modifications. While droopy drawers work for all but the thickest-tailed anthros, drawbacks include an excessive amount of exposed pelvis—not always appropriate or desired.

### Tailored Clothes

Redesigning traditional clothes to accommodate a tail is simple. A hole cut in the rear offers an easy escape, or consider a split-back design (like the one this cow anthro models) that fastens in the rear using the base of the tail as an anchor point.

## WHAT ABOUT GOWNS AND ROBES?

Even without a tailored hole in the rear, it's possible to guide most tails out of loose-fitting clothes like skirts, gowns and robes. But cramming a tail down a tight dress results in a lumpy silhouette along the back. Also, ask your anthro to be careful with her tail, as any sway can send clothes yanking up, down and all around—a big problem if modesty is a concern.

### Putting It All Together

This ermine knows how to dress. She wears a strappy halter top to give her furry shoulders room to breathe, pants with a hole for her tail and a cute ribbon around her tail for a touch of flair.

# Au Naturel

In the animal kingdom, where nudity is the norm, clothing can seem unnatural and, for many animals, redundant. After all, who needs clothing for warmth if you're already covered in a thick layer of insulating fur or feathers? Clothing also has the regrettable tendency to cover an animal's fur patterns. Here are a couple of ideas for handling fur in a way that allows characters to retain their modesty while showing off their distinctive markings.

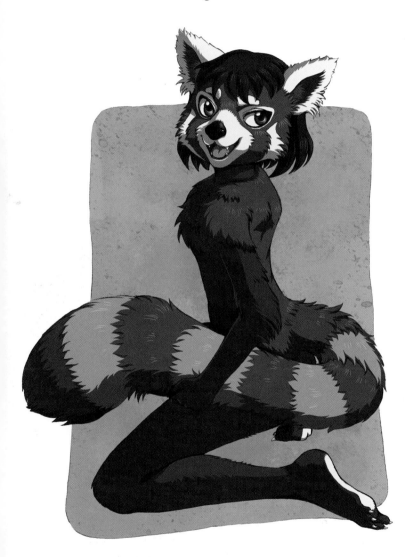

## Fur in Lieu of Clothes

This red panda smiles unashamed, knowing that her reddish brown fur covers her completely. To create fur patterns like the white facial markings, lightly sketch the divisions with jagged lines, then fill them in with the appropriate colors. Use shadow tones to help unify alternating colors, such as on the long bushy tail.

## A Sheep in Sheep's Clothing

Always be on the lookout for ways to make your character designs unique. For example, this ewe's fleece takes on the form of a woolly dress and matching cloven-hoofed shoes, complementing her human form without abandoning her sheep roots.

# Mountain Goat on a Bluff in the Buff

*The mountain goat's dense woolly coat insulates him from harsh winter temperatures. For anthro goats, the coat doubles as a barrier from prying eyes.*

### 1 Sketch the Upper Torso

Draw a circle with crosshairs facing upwards for a proud, upturned head. Sketch a strong, muscular torso and pull the guideline from the head down the center of the torso. Attach the head to the body with a tubular neck shape. Then, sketch the shoulder and leg sockets on the torso.

### 2 Complete the Figure

From the shoulder joints, draw the arms planted firmly on his hips. Draw the digitigrade legs sturdy and sure-footed; mountain goats are experts at climbing rocky cliffs. Draw each hoof and split it into two even toes (the space between them should resemble a missing slice of pie). Sketch a cubic block beneath his propped-up foot. Sketch a short, upturned tail. Fill in the goat's facial features: the ear, long muzzle, wide nose and pointy horns.

### 3 Add Fluff, Details and Color

Fill out the figure with a thick coat by layering bundles of fur. Strive for "fluffy" without completely obscuring his masculine figure. Keep the fur beneath the knees short. Draw the beard, head hair and elbow tufts with long, curving pencil strokes. Detail the horns with growth rings around the base. Break the boring cube into a textured, bumpy rock. Color your proud billy with some wintry whites.

# Color, Step By Step

From the time you first picked up a crayon, you've been think-ing about how to depict the world in color. Color adds an extra dimension to expression, allowing an artist to indicate form, mood and setting in a way black-and-white line drawings can't. In furry art, color lets you fully represent your fuzzy and feathery creations' natural hues and patterns, communicating to the viewer a particular breed or species. You can also use color in creative combinations to invent fabulous and fantastical never-before-seen creatures.

Every color picture begins with a series of decisions made by the artist: setting up the supplies, choosing the right colors and determining the light source before finally picking up that paintbrush to apply the colors. In this chapter, we cover the technical process step by step, leading you from those precoloring decisions onward to applying base colors, shadows, highlights and details. We also give you tips on how to use unnatural colors to create characters with unique magical qualities.

By learning the proper approach, it's easy to add a colorful touch to furry characters, whether they walk on two legs or four.

**When Foxes Flutter**
by Lindsay Cibos
10" × 11¼" (25cm × 29cm)

# Materials for Coloring

Color mediums come in two forms: wet (paints such as watercolors and acrylics) and dry (colored pencils or markers). Wet or dry, the medium you choose is up to you. There are no wrong or right tools for expressing creativity. Keep in mind that each medium has its own characteristics, so you may find that one is better than another for achieving certain effects. Some are easier to master, but they all require patience and practice to learn. Experiment to discover which mediums you enjoy, and, most importantly, have fun!

Examples of Dry Mediums

Examples of Wet Mediums

## TRADITIONAL MATERIALS LIST

You won't need all of these supplies to color your art. Think of this more as a list of suggested mediums to try rather than a shopping list. We recommend starting with the supplies you have readily available around the house, then expanding your repertoire as desired.

### Wet Mediums
- acrylic paints
- watercolors
- large brushes for broad, sweeping strokes
- small brushes for detail work
- paper or canvas appropriate for the medium
- water container
- palette for holding and mixing paint
- rags or paper towels

### Dry Mediums
- colored pencils
- markers
- oil pastels
- crayons
- paper appropriate for the medium

### Inking Supplies
- technical pens
- brushes
- nibs and holder
- black, waterproof ink
- water container
- eraser
- rags or paper towels

## INKING YOUR LINE ART

You can either color directly over clean pencil art (like many of the images in this book), or first apply ink over the pencil to achieve a dark, definitive line. Use technical pens, brushes or nibs to apply the ink. Keep a rag or paper towel handy for messes. After the ink dries, erase the underlying pencil lines and your inked drawing is ready for coloring.

## WATERPROOF FOR WET MEDIUMS

Always use waterproof ink. Otherwise, you might discover firsthand the horror of watching your inked lines melt into a smudgy mess after applying a water-based medium over them.

Drawing and Inking Supplies

## GOING DIGITAL

Using the computer is another option for coloring your artwork. To work digitally, you'll need a computer with plenty of speed and storage capacity, plus a graphics tablet for inputting brushstrokes (or infinite patience with a mouse). Of course, a good computer will get you nowhere without the software. Adobe® Photoshop® and Corel® Painter™ are the industry-accepted standards for professional artists, but cheaper alternatives exist for the budget-conscious.

## YOUR WORKING SPACE

It's imperative that your workspace be well-lit and comfortable, especially if you plan on spending a lot of time there. We recommend that your setup include the following: a desk with enough surface space to spread out, a desk lamp or good overhead lighting to minimize eyestrain, art supplies within easy reach and an ergonomic chair with good back support.

# Clouded Leopard Couple

Color can enhance the mood, suggest the time of day and define form and shape in a picture. In this multipart demonstration, we'll walk you through the process of coloring a clouded leopard couple, from selecting effective colors to finishing the piece with shadows and highlights.

## PART 1: COLORING PREPARATION

Before laying down your colors, you'll need to prepare your drawing. In many cases, you can color directly on the sheet of paper containing your original drawing as long as the lines are clean and the paper isn't falling apart from your earlier efforts. Some artists photocopy or trace their line work onto a new sheet of paper and then color the copy. If you're painting, you may need to transfer the lines to a medium better suited for holding paint. If you're coloring digitally, you'll need to scan the drawing for use in graphics applications.

### 1 Rough In the Characters

Sketch a pair of clouded leopards sharing a quiet moment. Multi-character pictures can be complicated, especially when characters overlap, so take care to block them in using basic shapes and construction lines. Then, roughly block in a forest setting around them.

### 2 Clean Up Lines for Coloring

While essential for drawing, construction lines can muddy up a color image and create confusion regarding which is the final line. For the cleanest image, erase any unwanted sketch lines before coloring. Remember, depending on the medium, once color is applied, it might be too late for erasing. A clean sketch clearly defines an object's edges and acts as a guide for color placement. Your clean sketch can be anything from a faint outline to a highly detailed draft. If you accurately indicate form with lines, color can fill out the rest of an image.

## PLANNING YOUR COLORS AND SETTING UP YOUR PALETTE

In addition to determining the general color for things like hair and clothing, you'll need to consider factors such as time of day, location and mood, all of which can impact the colors. It's a lot to think about. Experiment with color schemes on a separate sheet of paper, your color palette or on copies of the sketch.

A *palette* is the limited library of colors you've chosen for your picture. This can be a group of paints, a bundle of colored pencils or a computer file with dabs of digital color. For this demonstration, the characters are under the yellow-white midday sun, so choose bright base tones. Add to the palette as necessary.

## PART 2: LIGHT AND SHADING

*A picture with only base color tones looks flat. To give objects depth and volume, you'll need to build up your colors with shadows and highlights. Shadow tones are a shade or two darker then the base tone, while highlights are brighter.*

*Don't forget, solid objects block light and cast shadows on areas that would otherwise be in the light. Check your image to see if anything obstructs the light, and if so, depict that area in shadow. For example, in the demo image, the male leopard's arm casts shadows across his shorts and the female's stomach.*

### Shadows and Highlights, 1

Note how the surface areas exposed to the light source are the most brightly illuminated, while other areas stay darker.

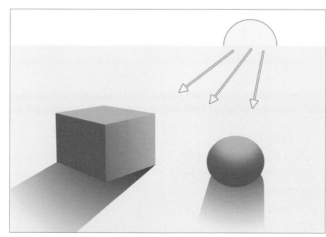

### Shadows and Highlights, 2

If the lighting source moves, the shadows and highlights change direction accordingly.

## LET THERE BE LIGHT!

The color and intensity of the light source in your image influences the colors. Try this experiment. Look at your clothes and describe the colors you see. Now, turn on a harsh yellow lightbulb and take note of the colors. Then, walk outside and compare those colors to those you see under sunlight. Finally, go to a dark place in your house. What colors do you see now? You'll find that colors you perceive for an object (in this case, clothes) aren't fixed. Instead, they depend on the qualities of the surrounding light.

Here are examples of the same image as depicted under two different lighting schemes.

### Afternoon Colors

Late in the afternoon, the sunlight shifts to a ruddy orange. The base colors become a rich orange. The bushes that appeared bright green under white light transition to a muddy yellow, and the blue toe-sandals shift to purple.

### Night Colors

In a true night scene, the light would be so dim and the colors so dark that it might be hard to see anything. However, you can simulate the feeling of night by shifting the colors to blue and using cool yellows to light the scene.

## 2 Determine the Light

Directing the light source is essential for creating convincing shading throughout your image. In this case, fix the position of light above the characters. This sort of lighting highlights the characters, and paints the underside of objects in strong shadows.

## 1 Lay Down the Base Tones

Using the medium of your choice, carefully fill in the areas of the picture with base color tones. In this image, the base tones represent the middle values for the picture, but if you're working with a medium that darkens as you build up colors, like watercolors or markers, start with the lightest tones. When you're done, the image will look colorful but flat. To create depth, you'll need to add shading.

## LIGHT FROM BEYOND

You don't need to see the light source in the picture to know it's there. Just make a mental note of where the light is coming from. In most cases, the light source makes its presence known from the play of light and shadow across the image. No miniature sun or floating spotlight is required.

## 3 Layer On the Shadows

Following the lighting model, brush or dab a shadow color with a hint of violet over the base tones. Keep things smooth, subtly blending shadows as you go. Make additional passes over parts of the image with darker tones where necessary. Occasionally use choppy strokes on the fur to indicate texture.

### 4 Build Up the Fur Texture

Add patches of short hair to make the body appear covered with soft fur. Working within the shadows, pick a darker color and dash in some hairs following the direction of the fur's grain. Follow this simple rule: fur travels from the top of the body down the torso, limbs and tail.

### 5 Layer On the Highlights

Using a color tinted brighter than the base tone, apply highlights in areas of the image most exposed to the light. Here, the top and front of objects are the most brightly illuminated. Like the shadows, gradually build the highlights while letting some of the base tone show through. As you work, continue to suggest soft fur by dashing short light-colored hairs throughout the coat.

## PART 3: COLORING FUR PATTERNS

*In this part, you'll learn how to put the finishing color touches on your clouded leopard couple including their fur patterns and the surrounding forest. Read on!*

### 1 Establish the Fur Pattern

With animal reference at hand, use a pencil to lightly denote the edge of the fur patterns on your characters. For this cat couple, use the clouded leopard's combination of small spots, open cloudy spots and stripes. Take care to correctly map the shape of the patterns to the bodies' contours.

### 2 Fill In the Patterns

Fill the patterns with a dark brownish black color. While going over previously shaded areas of fur, vary the light/dark intensity of the spots so they properly conform to the established lighting. Emphasize the fur grain with corresponding strokes inside and along the edge of the spots. As a final detail, brush sporadic light and dark hairs inside and outside of the spots.

### 3 Finish the Characters

To capture the intensity of bright sunlight shining down, use pure white and accentuate the most prominently lit edges along the characters' bodies. Use edge lighting like this sparingly to deliver a beautiful glow and create a satisfying pop between areas in a picture.

**4 Complete the Background**
Cover the character art with a mask to protect it while finishing the background. Start with the bushes, working from dark to light with dabbing strokes; make the clumps of foliage brightest at the top. Paint random twigs and branches into the underbrush. Scatter small leaf shapes throughout the foliage and over the twigs to suggest detail with minimal work. On the ground, start dark and build tufts of grass with drooping vertical strokes, or spots and slashes for rocks and debris. Progressively build up the color on the ground objects as you move towards the front of the image. Remove the mask.

## SIGN THE PICTURE

Don't forget to lay claim to your finished piece. Find a spot off to the side and tag the image with your signature. It's also a good idea to indicate a date. That way you'll be able to track your progress as you complete a growing stack of fur-filled art.

# Unnatural Colors

If you're trying to portray a particular species or breed, it makes sense to take color inspiration from your subject matter. But don't feel obligated to always stick with realistic colors. Color can also indicate that a character is unusual or fantastical, or even hint at his mood or habitat. Just because blue dogs and pink cats don't exist, it doesn't mean you can't create them in your artwork. Remember that you're the artist—when a picture calls for it, take your artistic license and use it.

## ICY BLUE DOG

Every color has an innate temperature: warm or cool. Reds, oranges and yellows fall under the warm category, while purples, violets and blues are cool. Knowing this, you can use colors to hint at a character's nature. Use reds and oranges to make a magical firebird sizzle with heat, or blues and purples to indicate an icy character.

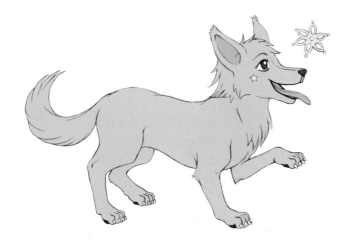

### 1 Apply the Base Colors
First clean up any stray pencil strokes or construction lines on your drawing. Then, use a light blue for the base color of the dog's coat. Blue is a cool color that evokes chilly imagery such as frozen ponds and snowy evenings—ideal settings for a magical character like this ice-elemental dog.

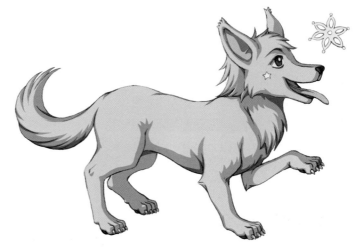

### 2 Build Up the Shadows
Choose a dark blue color for the shadows. Then, determine the light source and place the shadows accordingly. In this example, imagine that the sun is overhead and slightly to the dog's right, illuminating his side. Use a darker blue color for heavily shadowed areas, like the nook of the back left leg.

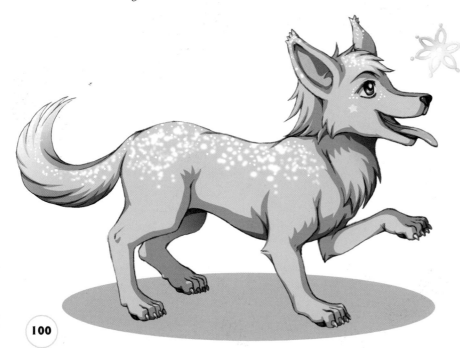

### 3 Add Special Effects
Layer flecks of white over the top portion of the dog's coat. Vary the size and hardness of the white spots. The color and shapes of these flecks add texture and suggest the imagery of freshly fallen snow, a fitting fur pattern for an ice dog.

## THE MAGICALLY MAGENTA CAT

If the sassy, confident expression doesn't give it away that this is a talking, fantasy cat (even normal cats act sassy and confident), one look at the pink fur and you know there's something unusual about this fuzzball.

### 1 Apply the Base Colors

Work in a basecoat of pinks (or another unusual color) over your clean line art to indicate that this feline isn't your average house cat. Use a lighter color for the fur ruff, paws and tail tip. Finish the basecoat with some white or light blue for the eye whites and ear hair.

### 2 Add Shadows and Highlights

Build up the form of the cat with dark pink shadows over the pink fur. Then, work in the remaining shadow tones. Be careful to line up the shadows where colors transition. Following the direction of the fur, add small white highlights to give the cat a fuzzier texture. Work in a purple drop shadow to ground the character, and the picture is complete.

### Rainbow Horse

Although there is plenty of diversity in horse coloration, horses are limited to earthy hues of brown, black, gray, white, yellow and variations thereof. Magical horses, on the other hand, can come in any color—green, orange, purple and so on. Now that's a horse of a different color! This image plays with color gradations to represent the full spectrum of the rainbow in the horse's coat, mane and tail. Use rainbow color schemes with caution; too many colors can look gaudy. Repeat some of the colors, such as the blue in the horse's hooves, eyes and bow, to unify the image.

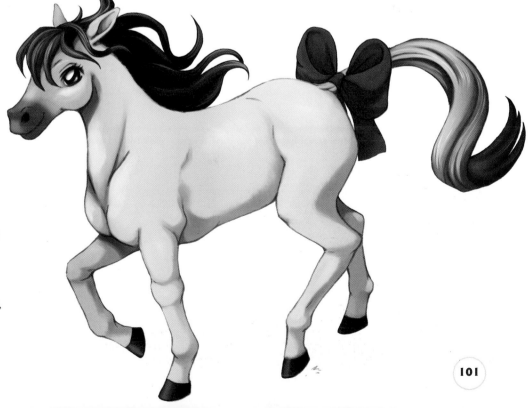

# Perspective and Settings

This is it—the final exam. So far, you have learned how to draw and color anthro characters of many different species. Now you'll get to try your hand at drawing entire scenes. It's fun to create characters and develop their appearances and personalities, but if you neglect to draw a background, the furries are floating in white space. It would be a shame to spend all that time working on your characters and then not give them a place to exist and be themselves.

Learning how to draw backgrounds will enrich your artwork. In a character-centric image, the setting may not be the focus, but it can add to the visual impact, turning a static character design into a scene that tells a story.

In this chapter, we'll show you how to first develop a setting that suits your characters and then construct it using the principles of perspective. No need to grab a hardhat—just a pencil, eraser, some paper and a ruler. Let's get building!

**Deviled Ham**
by Jared Hodges
8¼" × 10" (21cm × 25cm)

# Perspective Basics

Long ago, artists discovered that they could accurately represent our three-dimensional world on a flat, two-dimensional plane like canvas or paper by using a technique called *linear perspective*.

The three types of linear perspective you'll commonly encounter use one, two or three points. All types consist of the following components:
- Horizon line: A horizontal line representing the eye level of the viewer.
- Perspective lines: Lines that converge at a point on the horizon.

- Vanishing points: Points on the horizon at which perspective lines converge. You'll use one, two, three or more vanishing points, depending on the alignment of objects in your drawing.

## MATERIALS LIST

You'll need all the standard tools: your trusty pencil, eraser, paper and coloring medium plus a ruler to assist with drawing straight lines. Additionally, a T-square is a useful tool for drawing horizontal and vertical lines.

## Linear Perspective in Real Life

You can observe linear perspective at work in reality and photos. Converging lines are most apparent in the hard edges of man-made structures. Note how the sidewalk and road converge to a vanishing point on the horizon (blue line) in this photo.

## Characters in Perspective

The rules of perspective apply to both backgrounds and the characters inhabiting them. For help visualizing a character's spatial relation with the background, draw a box in perspective, the height of your character, then place the character inside it. Characters standing in a line share the same converging lines. If they are the same height, the horizon line will cut across each character in the same place (in this case, through the eyes) no matter how close or far away.

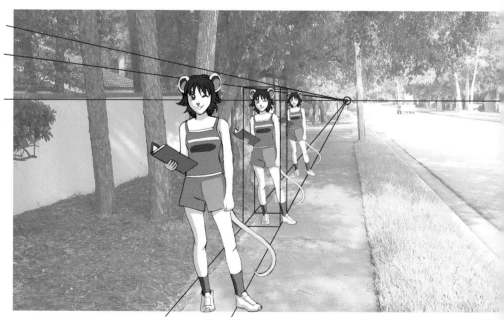

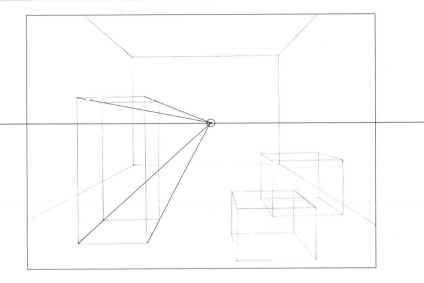

### One-Point Perspective

In one-point perspective, draw converging lines to a single vanishing point on the horizon. Draw horizontal lines parallel to the horizon, and vertical lines perpendicular to the horizon.

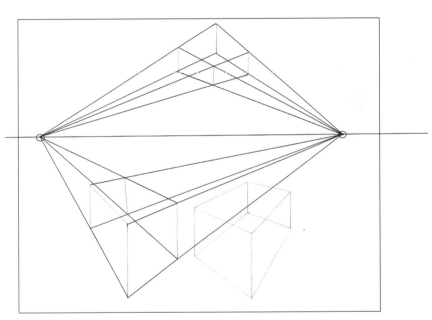

### Two-Point Perspective

In two-point perspective, use two vanishing points; draw the left side of an object receding to a point on the left and the right side to a point on the right.

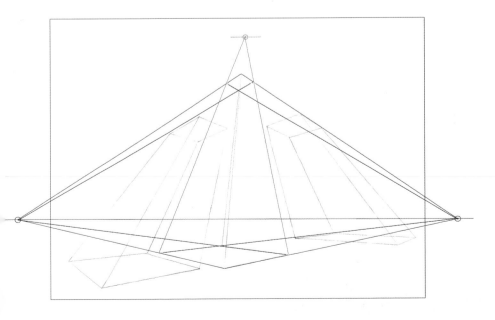

### Three-Point Perspective

In three-point perspective, start with two vanishing points on the horizon as in two-point perspective, then add a third point either above or below the horizon. This third point gives the picture a dramatic feel by emphasizing height. Three-point perspective is also called bird's-eye view (when the point is high) or worm's-eye view (when it's low). There are no horizontal or vertical lines in three-point perspective. All lines converge to a vanishing point.

# Bunny Sleepover Scene

*In this multi-part demonstration you'll walk through the steps of creating a bunny sleepover scene using one-point perspective.*

## PART I: DEVELOPING AN IDEA

*The first part of drawing any scene is to develop an idea for it and then the characters and objects that will inhabit the scene. Think of every detail, every object and every piece of furniture in an illustration as pieces of a puzzle. With everything combined, the scene tells the story. Like a detective examining clues, the viewer uses the things you include in your image to deduce what is happening. As the phrase goes, "A picture is worth a thousand words."*

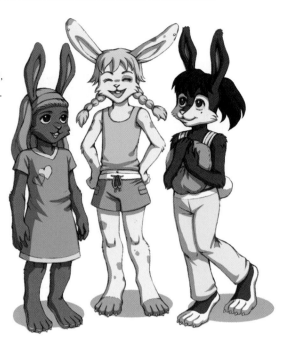

### 1 Design the Characters

Before jumping into drawing your scene, take some time to develop your characters. Get to know them: their personalities, what they wear, their height and build, notable physical features, their color schemes and so on. Sometimes a quick rough sketch is sufficient and details can be worked out in the actual illustration. On the other hand, if you plan on doing a complicated scene, or multiple pictures featuring the same cast, creating a design sheet with fleshed-out characters can be a real asset. Plus, the better you know your characters, the easier it will be to create poses for them.

### 2 Populate the Environment With Stuff

Think about the sort of objects you might find in your setting. Small details can make a large impact on the "feel" of a setting. It's an opportunity to tell the viewer about the characters and the environment. For example, in this girl's bedroom, we find a stuffed toy, a pair of skates and a video game system, which hint at the sort of things she likes. The assorted snacks and beverages suggest that a party is taking place.

### 3 Add More Stuff

Don't forget to include items in the setting that help it look inhabited. A bedroom setting might contain discarded clothing or decorative pillows strewn about. To match the personality of their bunny anthro owner, some of the items pictured here are rabbit-themed.

### 4 Pick the Right Furniture

The room in your scene will look empty without furniture. But don't start drawing just any old bed or dresser. The characteristics of the furniture you put in your scene tell a story about your characters. The style (retro, modern, etc.) and condition (brand-new to falling apart) of the furniture can suggest a character's tastes and wealth, and how long she's had the item. Moreover, an open drawer implies a messy character, a book on a dresser suggests a potential hobby, and a pretty scarf and matching purse are clues to the gender of the room's owner.

## PART 2: ROUGHING OUT THE SCENE

*In this section you'll develop your rough idea for a one-point perspective scene, find the horizon line and vanishing point, and begin to block in your basic shapes and characters.*

### 1 Brainstorm Ideas
Think about the scene you want to draw, and do a couple of thumbnail sketches on a scrap of paper depicting that scene in different ways. Thumbnail sketches, as the name implies, are small (generally no larger than a few inches wide), low-detail drawings that can be produced quickly.

### 2 Settle on a Concept
Look over all of your thumbnail sketches and choose the one you like most. Take into consideration the composition, overall feel and character poses. Although the frenetic pillow fight idea has its merits, let's go with this calmer scene of the bunnies eating snacks and playing video games together.

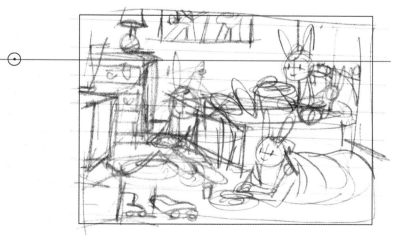

### 3 Establish the Perspective
Determine the type of perspective necessary to portray the scene. This takes practice, so don't be frustrated if you find it difficult to figure out the perspective at first. For tight indoor scenes like this, one-point perspective works well. Set the horizon line beneath the top of the dresser and above the bed, about three-quarters up the picture. Place the vanishing point on the left side of the horizon line. As is the case here, the vanishing point may not always be on the page. Attach a sheet of paper to extend your canvas if necessary.

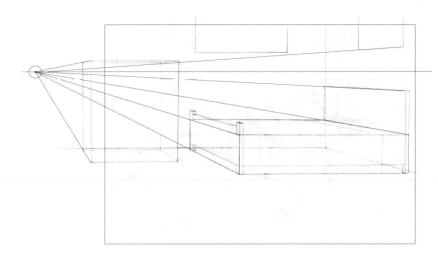

### 4 Block In the Basic Shapes

Using your thumbnail sketch as a guide, draw the horizon and vanishing point on a full-size sheet of paper. Draw the back wall with a line parallel to the horizon. From the corner of the room, use the vanishing point to pull out the side wall. Next, build up the basic rectangular shapes for the bed and dresser. Draw the sides converging to the vanishing point. Because the height of the dresser extends past the horizon line, don't draw the top side of it.

### 5 Draw the Television and Stand

All objects in a room are seldom perfectly lined up. Because the TV and stand are turned at an angle, they converge to their own vanishing points on the horizon line. Set a vanishing point on the horizon line at about the middle of the bed. Set the other point to the far left (it's really out there, so you may need to attach an additional sheet of paper to reach it). As with the other objects, draw all of the vertical lines perpendicular to the horizon line. Note that the scene is still in one-point perspective, as most of the objects converge to a single point.

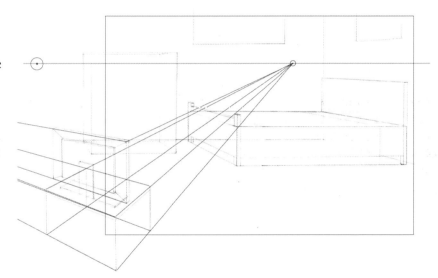

### 6 Block In the Characters

Using the poses from the thumbnail sketch, start building up the characters' figures. Be careful to keep them in scale with the scene; for example, the girl seated on the bed needs to be small enough so that if she fully stretched out, her legs wouldn't go over the edge of the bed. Note that like the furniture, characters conform to perspective. Pull diagonal lines on the two rightmost girls to the vanishing point on the left. For the girl turned at an angle towards the TV, use the television stand's vanishing points.

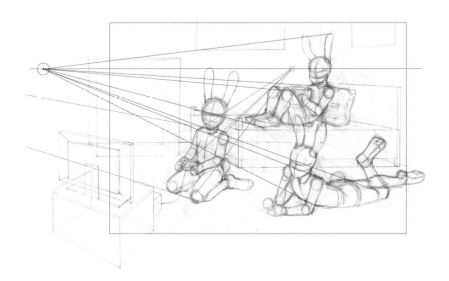

## PART 3: FINISHING THE SCENE

*In this section you'll put the finishing touches on the scene: detailing the characters, objects and background, and adding color.*

**1 Finish the Background Details**
Add details to the dresser, bed and television stand. Carefully erase guidelines as you work through your picture. Draw objects on the dresser slightly below the top edge (because the dresser extends above the horizon, the bottom of the objects are obscured from view). Sketch some additional objects on the bed and floor to give the room a messy, lived-in atmosphere. Remember to draw the objects pulling to your vanishing points.

**2 Finish the Character and Object Details**
Using your character designs as reference, fill in the characters' forms with details. Refer to the design sheet frequently to ensure that they remain on model. Give each character a unique facial expression to match her body language. Varying expressions give the scene a candid feel. Tighten all of your lines and erase any remaining guidelines or stray marks.

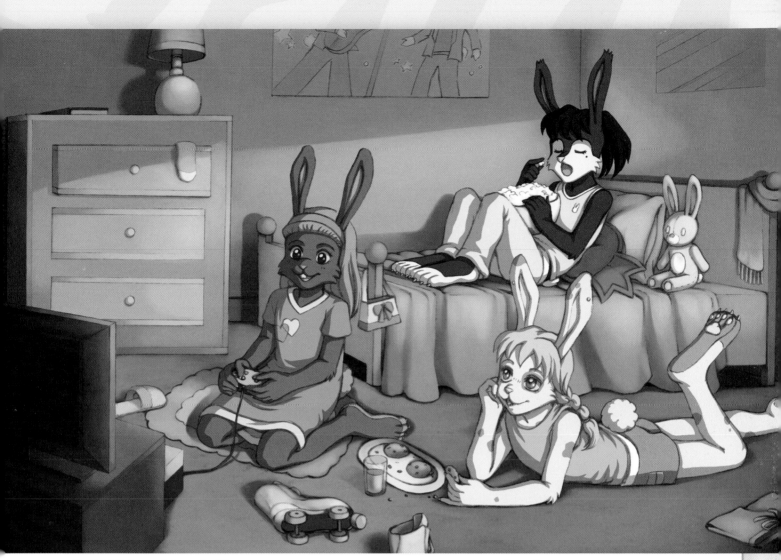

## 3 *Add Color and Crop the Picture*

Think about the lighting in your picture: Do you want the light source to be the lamp on the dresser, an overhead light, the sun through a window or the television screen? Block in your base colors and build up your shading reflecting your choice of lighting. Once you're done, examine the composition of the finished art and crop the image. Usually you would cut along the picture edge that you determined during the planning stages, but don't be afraid to change plans, even during late stages, if you find that something else works better. Here, extending the frame past the end of the dresser improves the composition.

Bunny Sleepover
by Lindsay Cibos
5½" × 8½" (14cm × 22cm)

# Ferret Thief Scene

In this illustration, a ferret steals a cherished object from a society of cats, leading to his pursuit through a maze-like garden. The ferret, full of quiet cunning, evades the cats and makes off with the prize, a crystal kitten icon. This idea stems from an actual incident when a ferret collected a cat's errant toys and hoarded them away in its own hidden clutch.

## PART 1: DEVELOP AN IDEA

All images have the ability to tell a story. Depending on what you put into the image, the story can be anything from an introduction to a character's personality to an elaborate exploration of a subject.

Establish the "five Ws": In illustration, characters are the "who," setting is the "where," their action is the "what" and the "how." It's often up to the audience to figure out the "why" for themselves based on hints within the picture.

When working on a complicated scene, it's helpful to lock down designs as much as possible before proceeding. By designing elements early on, you need to worry only about composing the drawing when it comes time to create the final image.

### 1 Sketch Character Concept

Make several quick studies of the characters to figure out their anatomy and proportions (note the elongated upper torso of the ferret compared to the evenly proportioned cat character). For help with clothes, refer to online resources and books collecting historical clothing designs. Pick concepts that work for the characters and then add your own ideas. Eventually you'll arrive at a design that signals to the viewer who the characters are and what their roles are in the image.

### 2 Sketch Foreground Concepts

Because of its prominence, foreground scenery often demands an attention to detail similar to the character art. While tight drawings can wait for the final image, make rough studies and create an inventory of objects.

### 3 Sketch Background Concepts

In outdoor shots, the landscape gradually recedes towards the horizon. In the distance, trees, mountains and other structures lose detail, blurring into faint impressions of color and form. While many distant features don't need predevelopment, it is helpful to figure out complex objects like this castle and iconographic banners in advance. These background details hint at a living world beyond the scope of your picture.

### 4 Design a Cat Castle

From the ground, a castle is a series of walls and towers, but seen from the air, castles often reveal interesting geometric forms. For fun, design the cat castle to appear as a feline face from the air, with walls depicting the outline and towers as eyes and other details. While these whimsical ideas have little impact on the final image, coming up with fun concepts can lead to new ideas and keep you engaged with your picture.

## PHOTO REFERENCE

Photographic reference allows you to analyze and recreate fur patterns, body proportions, foliage and other details. Reference photos of animals and humans are a useful springboard for designing anthro characters; outdoor photos or gardening books can help inspire your composition and provide an assortment of plants and architecture for your image.

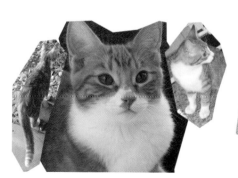

### Kitten Photo Reference

These are photos of a stray kitten whose brilliant orange tabby pattern, youthful appearance and innocent expression set him as the ideal model for the heroic (but inept) soldiers of the Cat Kingdom.

### Ferret Photo Reference

Pets are a great resource for observational reference. Acting as inspiration for the villain, ferrets' energy and curiosity make them remarkably hard to photograph for reference. Stay still!

### Outdoor Photo Reference

When developing an outdoor setting, compile reference material that will assist you in capturing types of foliage, trees and other organic details as well as the flow of shifting colors across the landscape.

## PART 2: ROUGH OUT THE OUTDOOR SCENE

*In this section you'll work your two-point perspective scene idea up from a rough draft, find the horizon line and vanishing points and block in the background.*

### 1 Conceptualize the Composition

Working from your basic idea and reference material, concentrate on creating a simple thumbnail sketch that incorporates your characters and important image elements. Sketch freely. Reposition elements and approach the image from different angles, making as many thumbnails as necessary. When a composition comes together that best captures your idea, place a frame around it to represent the image's cropped state.

### 2 Frame the Composition

Framing has a tremendous effect on how a picture feels. In general, wide frames create a cinematic presentation, good for depicting landscapes; tall frames focus more tightly on characters. Try recreating your thumbnail in a wide frame, pulling out and greatly increasing the size of the scene in relation to the characters. While the scene loses some of the dramatic tension present in the tight, boxy composition, it gains a sense of openness, emphasizing the world as much as the characters running around in it.

 **Set Up the Two-Point Perspective**
Look for natural guides in the composition to help lock down the two vanishing points on opposite sides of the image. Use the horizon line and vanishing points as guides to tighten the composition. Align the tops of the cats' heads with the horizon line, indicating that they are the same height as the ferret. Place the castle on a bluff high above the horizon so it towers over the garden below. Align objects and paths in the garden with the vanishing points.

**Block In the Setting**
Expand the rough composition to the desired size of your final drawing. Using the rough draft as a guide, reestablish the vanishing points and horizon on this fresh draft. Then, rebuild the background with a higher degree of structure than in the rough composition. Fix objects in place and align everything to the proper vanishing points. It helps to reduce complex structures like trees, pillars and foliage to basic geometric shapes so that they're easier to depict in perspective.

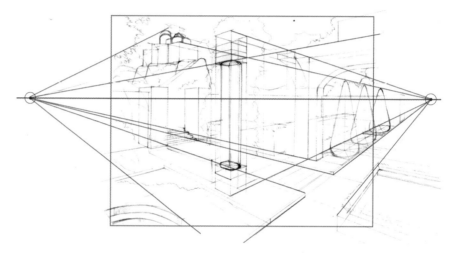

**Complete the Setting Sketch**
With the general forms blocked in, refine the background, adding detail to the cat-made structures. Elaborate on the simplified plants by creating semi-amorphous silhouettes around patches of foliage that give the impression of different leaf shapes and plant types. Shade the line work with the side of a pencil or use hatching lines to add texture and distinguish objects. Add small details like fallen leaves and cracks in the masonry. Don't get so carried away with the background that you forget to leave room for the characters.

## PART 3: FROM CHARACTERS TO COLORING

*In this section you'll add life to the scene by populating it with characters, working them up from basic shapes to detailed forms. Then, you'll establish a lighting model and add color to create the finished piece.*

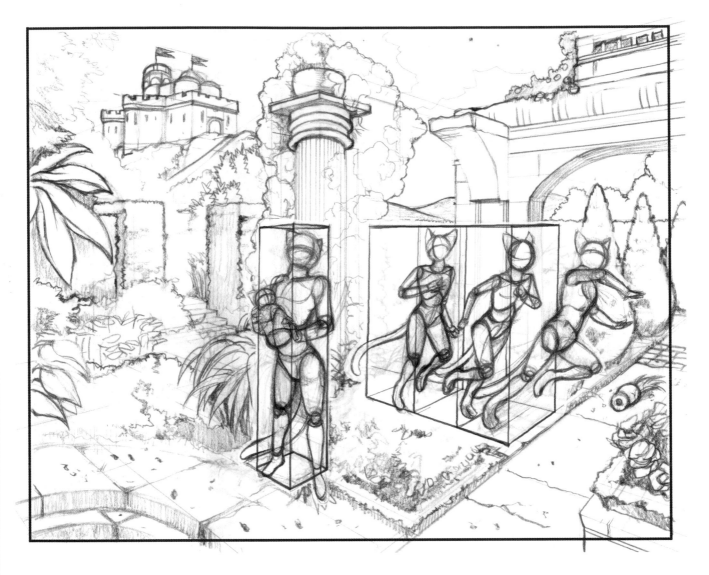

### Block In the Characters

Begin blocking in the basic character poses, either directly on the background art or on an overlaid sheet of tracing paper. Refer to the designs you made earlier for the characters' build and proportions. Place a cube around the characters to help place them in the background and keep them properly aligned with the image's perspective. Draw the stationary ferret with a vertical but sinuous line of action. Depict the sprinting cats with a forward-leaning line of action to give them the feeling of momentum.

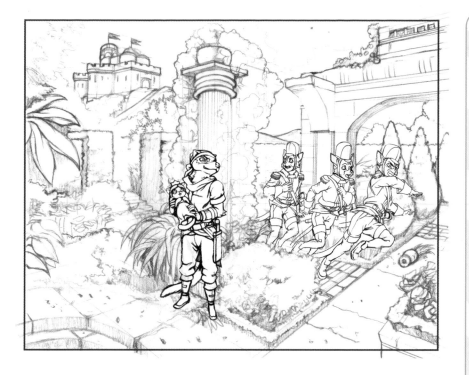

## 2 Finish the Character Art

Refine the character art, pulling clothing and character details from the design sheet. Keep the level of detail consistent between the background and character art. Look for ways to simplify the characters' designs. Emphasize body language and expression. The characters' ability to "act" through your art defines their roles in the scene.

## ACTORS ON THE SET

It's sometimes easier to sketch characters on a piece of paper separate from the background. However, to complete your picture you'll eventually need to recombine characters and background using one of several techniques. One technique involves cutting and pasting using either digital or traditional tools. Excise the characters from their sheet of paper, carefully lay them on top of the background art, and redraw any portion obscured in the move. Another technique is to place the rough character sketches underneath the background art and use a light box to trace the characters into the background.

## 3 Test Colors

Do a couple of quick color sketches on copies of the line work to provide a basis for the image's color palette. In this case, we went with a palette representing bright afternoon light, with the ferret character obscured in a region of shadows cast by the garden's extensive foliage.

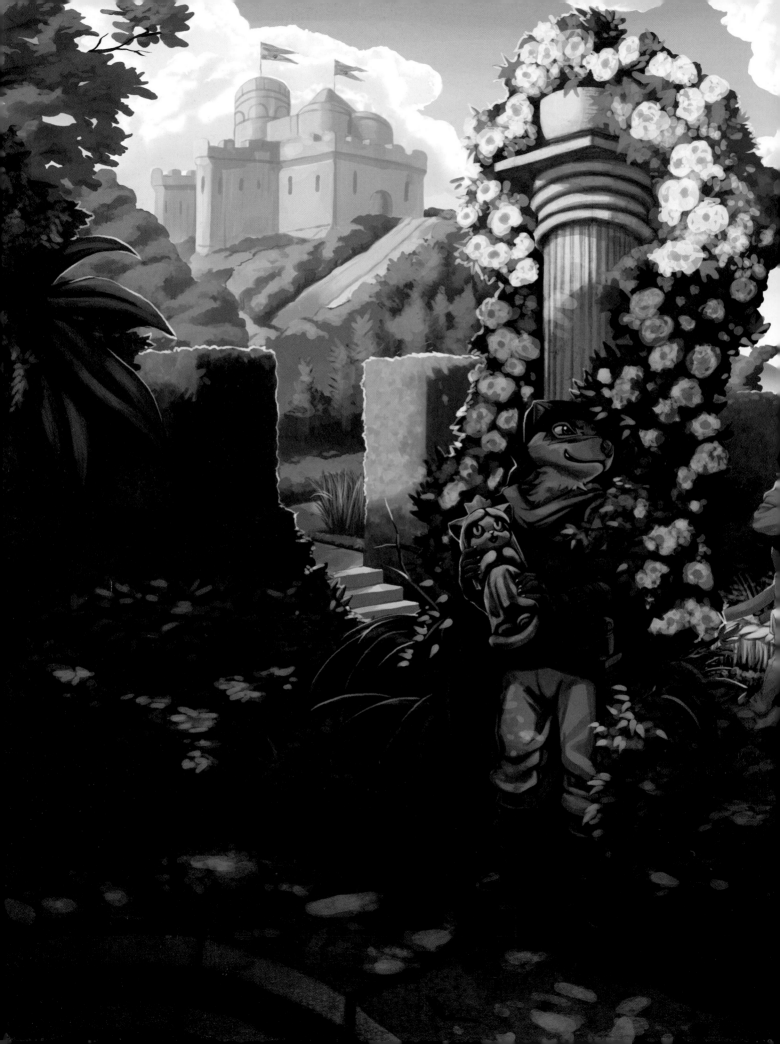

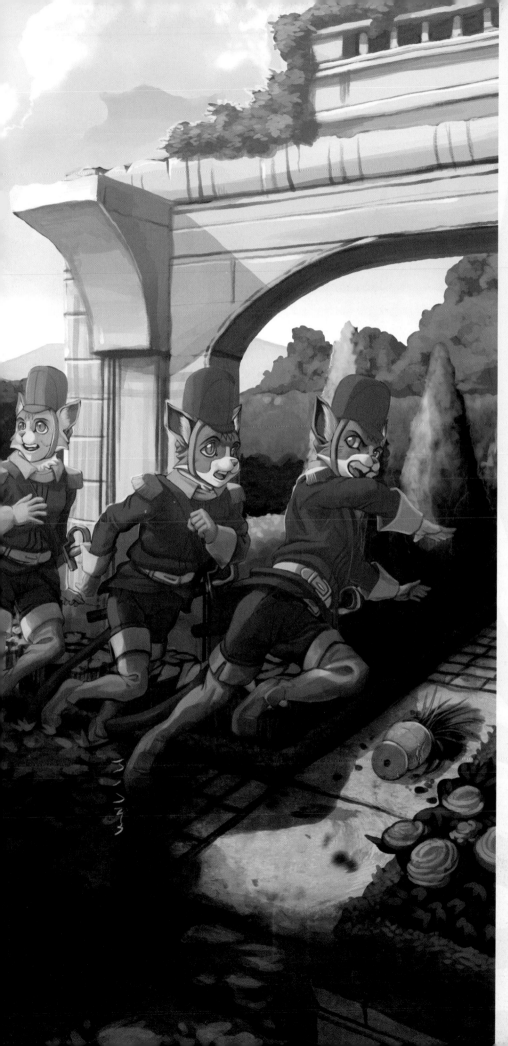

## 4 Add Color

Color the picture from back to front, finishing one section at a time. Keep the details sparse for objects far in the distance, and render them with a limited palette of dull colors. Progressively increase the detail and color depth as you move towards the front of the image. Use dark blue shadows to cloak the ferret and the surrounding garden in relative darkness. Cast the cats in bright yellow sunlight. This dramatic value and color contrast splits the image into sections that stand out from one another.

**Thieving Ferret**
by Jared Hodges
6½" × 8½" (17cm × 22cm)

## THE LONG HAUL

Remember, the bigger the picture, the more time it takes to produce. Take breaks, work on other projects or engage in physical activity. Breaking up the task will help to relieve any tension or frustration you feel while working on a complicated picture. Good luck!

# Guests' Gallery

Welcome to the art gallery showcasing fun and exciting anthro art by various artists. Enjoy!

Visha Ponders
by Rose Besch

Minori
by Marie Blankenship, aka Makime

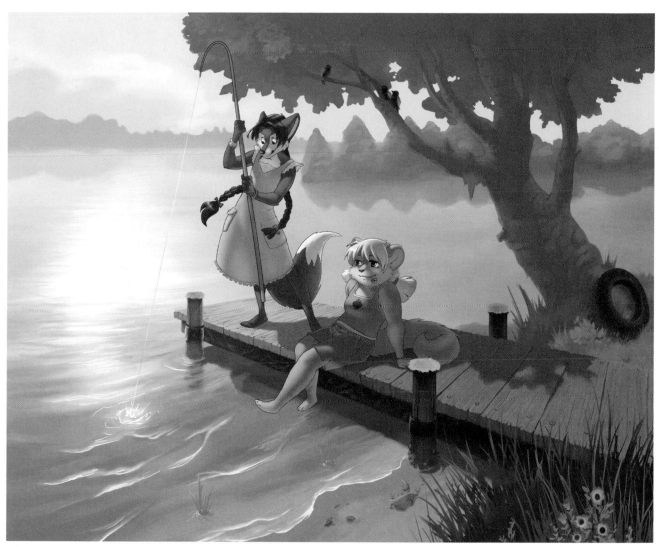

Fishin'
by Kelly Hamilton

Breakfast Time Peaches
by Miu, aka CookingPeach

Chibi Quad
by Rose Besch

# Authors' Gallery

Here are some additional illustrations by the authors, Jared Hodges and Lindsay Cibos.

These characters are part of a series of twelve inspired by the signs of the zodiac. Astrological signs (also characters from mythology, fairy tales and so on) are great sources for sparking imagination. Design cues for each character were taken from the details of the sign they represent. For exam- ple, Leo is the sign of leadership, symbolized by the lion and associated with the color gold. These details created a proud and noble lioness cloaked in warm colors reminiscent of the sign, another symbol of Leo.

The smaller, 3-heads-tall versions are simplified designs re-imagined with an emphasis on "cute."

## COLLABORATIVE EFFORT

The zodiac characters here are a product of heavy collabora- tion. Before creating the finished pieces, Jared and Lindsay each came up with multiple sketches for their designs. Jared combined the best ideas to create the final, full-size character pieces, which he and Lindsay colored together. Lindsay then used these images to create the cuter 3-heads-tall versions.

Tiny Zodiac Leo

Zodiac Leo

Zodiac Aries

Zodiac Taurus

Tiny Zodiac Aries

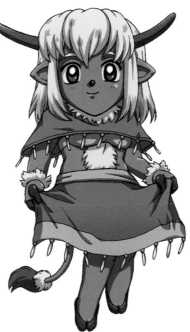

Tiny Zodiac Taurus

## PRACTICE MAKES PERFECT

One final tidbit of advice for aspiring artists: Keep practicing and refining your skills. Never give up, even when things seem impossible. Art cannot be learned overnight. If you stick with it, your efforts will be rewarded and you will improve. Good luck and happy drawing!

# Index

# If you're going to draw, draw with *IMPACT*!

Create fabulous shojo manga clothing and characters with different looks, primarily in pencil and ink. Loaded with techniques and tips, this book demonstrates the Japanese comic-book practices of stylized proportions, clean lines and contrast between black and white and finished art in color. You will also learn how to draw stylized bodies, clothing and accessories that will individualize your character's personality, all in a step-by-step format that will make it simple for you to pull every element together.

**ISBN-13: 978-1-60061-180-3**
**ISBN-10: 1-60061-180-X**
**Paperback, 144 pages, #Z2702**

Learn how to create, sell and publish manga comics and graphic novels using advice from the author and other successful industry professionals. Learn how to space comic writing, create word balloons, ink, tone and stylize your drawings with coloring techniques. Use step-by-step demonstrations to learn how to create manga, from the initial sketch to the finished product.

**ISBN-13: 978-1-58180-985-5**
**ISBN-10: 1-58180-985-9**
**Paperback, 128 pages, #Z0842**

Discover the drama, high romance, and dream-like settings of shoujo manga. Page after page of step-by-step instruction lets you get right to it as you learn the simple tricks to drawing different shoujo looks.

**ISBN-13: 978-1-58180-809-4**
**ISBN-10: 1-58180-809-7**
**Paperback, 128 pages, #33487**

## IMPACT-Books.com

- Connect with other artists
- Get the latest in comic, fantasy, and sci-fi art
- Special deals on your favorite artists

These books and other fine *IMPACT* titles are available at your local fine art retailer, bookstore or online supplier. Also visit our website at www.impact-books.com.